THE ESSENTIAL ™

Willem de Kooning

BY CATHERINE MORRIS

THE WONDERLAND
PRESS

Harry N. Abrams, Inc., Publishers

THE WONDERLAND PRESS

The Essential™ is a trademark
of The Wonderland Press, New York
The Essential™ series has been created by The Wonderland Press

Series Producer: John Campbell
Series Editor: Julia Moore
Project Manager: Adrienne Moucheraud
Series Design: The Wonderland Press

Library of Congress Catalog Card Number: 98-074610
ISBN 0-8362-1933-3 (Andrews McMeel)
ISBN 0-8109-5811-2 (Harry N. Abrams, Inc.)

Distributed by Andrews McMeel Publishing
Kansas City, Missouri 64111-7701

Unless caption notes otherwise, works are oil on canvas

Printed in Hong Kong

Harry N. Abrams, Inc.
100 Fifth Avenue
New York, NY 10011
www.abramsbooks.com

Contents

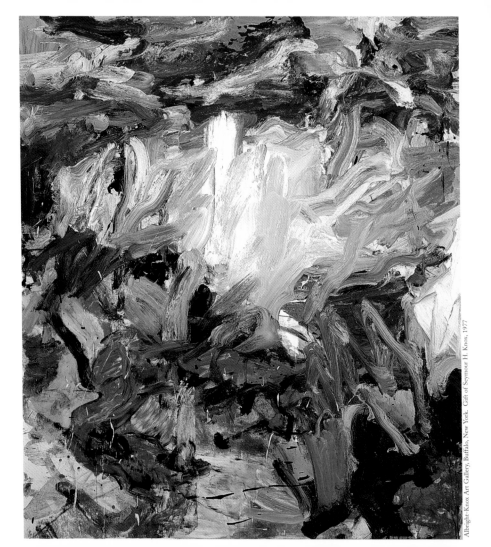

This is...Art?

Don't you hate it when people rave and carry on about paintings that look utterly meaningless to you? There's a splash of orange and a splotch of yellow, with a crest of stormy blue and squooshes of gray, and zigzags of green—and the painting is preposterously titled... *Untitled V.* What *gives* here? *This is art?? People pay millions for this??*

OPPOSITE
Untitled V
1977
79 ½ x 69 ¼"
(200.34 x
174.51 cm)

Well, yes they do, and maybe the title isn't so preposterous.

If you're already a big fan of modern art, fantastic! Hopefully, this book will feed your passion for these works. But if you look at abstract paintings and think, **"Why do people like this stuff?** *What's going on here?"*, then this book is for you. It will forever change the way you look at—and feel about—modern art. And you'll have a new best friend the next time you visit an art museum: the modern-art wing!

De Kooning is Hot

Willem de Kooning (1904–1997) is one of the hottest painters of the 20th century, and as you read his story, any discomfort you have with "modern" art will vanish. His energy will *pull you into this marvelously strange world* of abstract art and gradually let you enjoy modern art on *your* terms, in a way you can relate to. Once the door is open, you'll be

open, you'll be on the other side and will have hours of fun at future museum exhibitions and in conversations with friends. (Warning: Once you know what's going on in this art, you'll smile when you hear how others explain it. Instead of being bewildered, *you'll* be the one deciphering the code and interacting personally with the canvases.)

The main reason people are puzzled by modern art is that there is little recognizable in it. None of the standard signs that help us explore a painting seem to be present—no horizon, no landscape, no human figures. Faced with such disorienting canvases, the best way to begin enjoying these works is to forget about *meaning.*

A Sexual Response

You'll actually feel **an emotional charge** when you look at a work by de Kooning. His colors and energy will arouse in you a kind of subliminal **firestorm of sensuality,** and you'll soon know why people pay millions for his art. Strip away the notions of seriousness or importance or an artist's place in art history; go with your gut. Laugh at the marvelous ridiculousness of a canvas; enjoy the artist's fevered brushstrokes; indulge in the dialogue that he invites with his work.

De Kooning is known as an Abstract Expressionist (we'll get to this in a moment), even though he rarely made a painting that was purely abstract or that lacked all identifiable subject matter. Natural references usually lurk somewhere in a de Kooning canvas or drawing,

sometimes explicitly, often submerged under gallons of paint and years of effort. The female figure and the landscape are de Kooning's most compelling creative engagements. Alternating, juxtaposing, and merging the two for more than seventy years, he painted, drew, and, for a period in his late sixties, sculpted the figure and the landscape.

The Dutch Master was a Master Draftsman

The key thing to know about Willem de Kooning is that he could draw. He was one of the best draftsmen of his time and saw things nobody else did, then drew them brilliantly. Rigorously trained from an early age, he enjoyed the combination of technique, strength, and assurance in his hand. In de Kooning's best paintings and drawings, his technical prowess shines through the aggression and the bravura; it holds things together and makes them work.

As the artists of postwar New York grappled with existential ideas, a new style of painting began to evolve which expressed their preoccupations. Characterized by abstract imagery, loose brushwork, and large, dramatic "gestures," the new style was thought to represent some crucial psychic drama depicting subjective emotions rather than objective reality. This style soon became known by several different names, including Painterly Abstraction and Action Painting, but today it is best known as **Abstract Expressionism** (sometimes shortened to AbEx) or the **New York School**. Two easy features to spot are a sense of emotion and a genuine physicality.

Confronted with such a painting by **Willem de Kooning, Arshile Gorky** (1904–1948), **Jackson Pollock** (1912–1956), or **Franz Kline** (1910–1962), one way to get into the work is to imagine the act of making it. The way the paint looks describes how it was actually applied to the surface of the canvas. Abstract Expressionism is about the act of moving paint around and leaving the traces of that movement. No attempt is made to hide the process of painting. With this in mind, you can experience an emotional and physical response to the work of art and immediately begin to overcome any fears you may have of not *getting* abstract works.

The Essential Willem de Kooning

Willem de Kooning was one of the radical painters associated with the Abstract Expressionist movement. As a defining member of the most influential art movement created in the United States, de Kooning— along with Pollock, Kline, and **David Smith** (1906–1965)—is variously credited or damned for having turned post-World War II art on its head. Whichever side of the argument you're on, the truth is that de Kooning played a major role in forever changing the world of art.

Any accurate description of Willem de Kooning will likely include the word *radical*. But it might also contain the word *traditional*. In his training and choice of subject matter—and even his creative

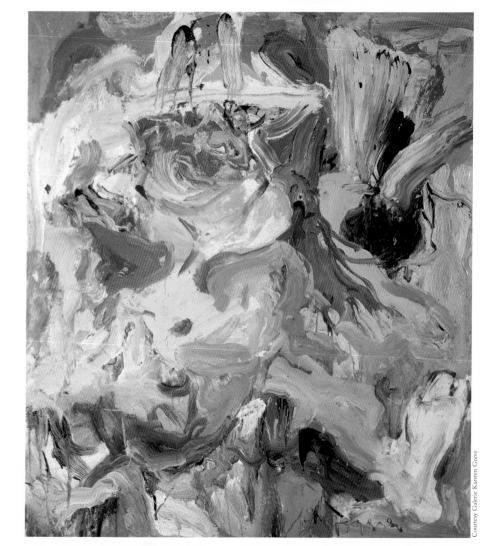

obsessions—de Kooning displayed a profound respect for the traditions of Western art. He viewed himself as a painter working *within* the parameters of art history, not against them. The artists he measured himself against were certainly his contemporaries—Pollock, Kline, and, above all, Gorky—but they were just as frequently figures from the history of art—**Jean-Auguste-Dominique Ingres** (1780–1867), **Pablo Picasso** (1881–1973), **Henri Matisse** (1869–1954), or the unknown painter of a Pompeiian fresco.

FYI: **Correct spelling**—You'll frequently see the artist's name spelled incorrectly. The correct spelling is **Willem de Kooning,** with a lower-case "d," unless "De" is the first word of a sentence. Obviously "William" is wrong, too. In 1936, de Kooning experimented with dropping the "de" from his name, thinking it catchier to be known as "Kooning." But "de Kooning" is a humorously obscure way of saying "The King" in Dutch, so he kept the "de."

A Broken Family in Rotterdam

And so the story begins: Willem de Kooning is born April 24, 1904 in Rotterdam, the Netherlands. His parents divorce in 1907 and the three-year-old Willem becomes a pawn in an unpleasant custody battle. The court initially grants custody of the child to his father, **Leendert de Kooning** (1876–1955), while his mother **Cornelia**

Nobel de Kooning (1877–1968) is given protection of Willem's older sister **Maria Cornelia** (b. 1899). De Kooning's mother will have none of this and effectively kidnaps her son, and, upon appeal of the court's decision, he is legally awarded into her care.

Both parents remarry in 1908 and have more children. Leendert, a successful distributor of wine, beer, and other beverages, plays little part in his son's life after his remarriage.

Cornelia, on the other hand, holds a predictable, dictatorial place in Willem's life. As the owner and bartender of a sailor's café (note: a proclivity for drinking becomes a major subtext in de Kooning's life early on), Cornelia lives into her nineties and even her own children refer to her as an abusive tyrant. It isn't surprising when critics later mention her as the motivating force at the Freudian root of de Kooning's famous "Women" paintings.

A Teenage Dropout begins Vocational Training

In 1916, de Kooning leaves grammar school and is apprenticed to the commercial art firm of Jan and Jaap Giddings. At age 12, his regular schooling effectively ends. While working at tasks such as lettering and painting signs for twelve hours a day, he impresses his employers with his talents. They encourage him to enroll at the nearby **Rotterdam Academy of Fine Arts and Techniques,** where he studies for eight years, graduating in 1924 as a certified artist and craftsman.

His experiences there make such an impression on him that more than half a century later he will still make reference to his early lessons.

Sound Byte:

"If you want to be an artist, it's not by having original ideas, but by working your way through it."

—WILLEM DE KOONING

OPPOSITE
Still Life: Bowl, Pitcher, and Jug
c. 1921
Conte crayon and charcoal on paper
18 ¹/₂ x 24 ¹/₄"
(47 x 61.6 cm)

The academy stresses both the commercial and academic aspects of making art. At the time of his studies there, art is viewed as a technical skill to be learned and used in a vocation. When you finish school, you are supposed to be trained well enough to get a job that pays enough to support you. The emphasis is not on individual creativity or quirky talents, but on the tools of the trade. De Kooning is one of the best pupils in his class. Within a couple of years, only a few of his original classmates remain at the school, and as the crew dwindles, the few who stick it out are the ones with the talent and tenacity for the task.

One of de Kooning's earliest surviving works, *Still Life: Bowl, Pitcher and Jug*, c. 1921, is a still-life drawing of crockery made at the Academy. The drawing is a beautifully realized study of form, light, and perspective that contains all the elements of a successfully accomplished technical exercise. Drawn with a stippling technique that is

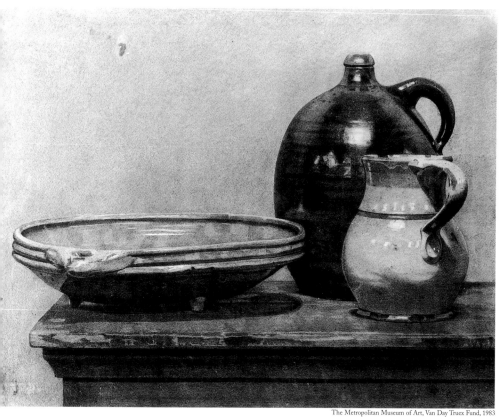

passed along to the advanced students as a guild secret, the illustrative qualities of the work win de Kooning high marks. It's tempting to search for signs of the acclaim we know the future holds. But can we find them here? Not easily. The drawing is exquisite, with an exceptional sensitivity, but our 20/20 hindsight makes it difficult to be objective about what this might mean. Aside from its obvious grace, the importance of the drawing lies in the insight it sheds on the teenaged Willem's exacting approach to his craft.

The Commercial Artist Learns about Modernism

At this point in his life the commercial aspects of art interest de Kooning more than the academic or "fine art" approaches. The bottom line is that **he's interested in making a buck.** The young student wants success in all the normal bourgeois ways, and as far as de Kooning and his pals at school are concerned, Art is the product of a bunch of dead guys.

In 1920, de Kooning begins working as a commercial artist in a department store in Rotterdam. Through a supervisor, he is introduced to some of the important modern art being made in Holland, Germany, and Paris. He is particularly taken by:

- **de Stijl** (active 1917 to 1931), a style concerned with pure abstraction in art, architecture, and design. Originating in the Netherlands, the name literally means "The Style." As the use of the article "de" implies, The Style was obviously meant to be

distinguished from ordinary, run-of-the-mill, "styleless" styles.

- **Jugendstijl,** the German Art Nouveau movement known for its interest in synthesizing and harmonizing the fine and applied arts.

- **Cubism** (active 1908 to 1918), the most important idea for art in the 20th century. In an attempt to challenge the conventional understanding of how space is rendered, Picasso and **Georges Braque** (1882–1863) developed Cubism. They did not, however, coin the name. That laurel goes to a less-than-sympathetic critic who thought that what Picasso and Braque were up to bordered on an idiotic rendering of little cubes.

With some experience as a commercial artist under his belt and some idea of current happenings in the art world, de Kooning spends 1924 and 1925:

- Traveling with other students and visiting museums in Belgium.

- Living in Antwerp and Brussels with friends.

- Supporting himself painting signs (he really gets into lettering), drawing cartoons, and designing window displays.

Loves American Pop Culture

While learning about European modernism, de Kooning becomes fascinated by American popular culture. Thanks to his friends, he

knows about Frank Lloyd Wright, Walt Whitman, and cowboys. The things that intrigue him—as revealed in the made-for-TV documentary *De Kooning on de Kooning*—have little to do with fine art. In fact, he doesn't even know there are artists in the United States. At the time, no one in Europe—and few people in America—think of Art as something that happens anywhere west of Paris.

Yet de Kooning emulates American illustrators. He sees American magazines and wants to do what those guys are doing with their pictures of the 1920s' good life. In fact, de Kooning yearns to come to America for all the clichéd reasons—to see the world, to make something of himself, and to succeed in ways that don't seem possible in quaint old Rotterdam. Clearly the "better life" he seeks is far removed from any notion of being an artist, since, in the 1920s, if he wants to be an artist, he must set his sights on Paris, not Hoboken.

The Stowaway arrives in Hoboken

A young and poor romantic, de Kooning decides that the best way to get to America is to jump a ship. He and a friend board the *S. S. Shelley* in Rotterdam and arrive in Newport News, Virginia, on August 15, 1926. (He almost boards a boat to Buenos Aires by mistake, but the fate-of-the-art-world-as-we-know-it is at stake and his clairvoyant friend redirects him to the correct boat.) From Virginia, de Kooning gets a job on a coastal boat headed for Boston.

Then there's a train ride to Rhode Island, where he boards yet another boat, this one bound for Manhattan's South Street port. Finally, he catches the ferry to Hoboken, New Jersey—across the Hudson River from Manhattan.

Getting A Life

At the time de Kooning arrives, Hoboken is home to a large Dutch community, which is good for de Kooning, since he doesn't speak a word of English. In spite of that handicap, within a short time he has:

- A room in a Dutch seaman's house.

- A job as a house painter, earning nine dollars a day.

- An opportunity to visit Coney Island, Brooklyn, where he loves to look at the people.

- A chance to visit Times Square, where he is thrilled by the lights.

Ah, New York!

In his early years in New York, de Kooning hangs out with a variety of creative types. His friends include circus performers and vaudevillians, and he has a girlfriend who performs as a tightrope walker at a local movie house between reels. Before the 1929 stock-market crash, New York City is hopping. In the years just after World War I, an influx of

*Triptych (Untitled V, II
and IV).* 1985
80 x 228"
(201.60 x 574.56 cm)

intellectual European émigrés hastens the acceptance of modernism in the city, and by 1927 de Kooning's life changes. He moves to a studio apartment in Hell's Kitchen, in Manhattan's West 40s, and takes a job as a commercial artist, even though it pays less than painting houses in Hoboken. In 1929, The Museum of Modern Art (MoMA) opens, as do galleries showing works by American and European moderns. America's first generation of modern collectors avidly buy art in New York and in Paris.

During those first years in the city, de Kooning makes some art but later disclaims this. For a long time, he is merely a weekend painter and, because he considers his work not very good, he destroys most of the art he makes during the 1920s and 1930s. Even though he isn't yet working as an artist, he starts very early in his Manhattan days to live a painter's life.

The famously gregarious de Kooning starts forming friendships with artists in the late 1920s. Disproving his earlier naïveté, it dawns on him that interesting people who take art seriously do exist in the United States, and in fact some of them happen to live nearby. De Kooning has a fortuitous knack for meeting and befriending fellow artists. By 1929, he's acquainted with three important artists whose work encompasses some of the most and challenging and ideas of the time. He considers himself fortunate to have met "the three smartest guys on the scene": Arshile Gorky, **Stuart Davis** (1894–1964), and

John Graham (1881–1961). The Russian-born Graham challenges people's thinking about art and teaches de Kooning about current European art. Davis is one of the first American artists to merge popular culture, figuration, and abstraction in his animated and colorfully charged canvases. The singlemost enduring creative influence for de Kooning, however, is the sophisticated, intelligent, and sensitive Arshile Gorky. Theirs is by far **the most profound and inspirational friendship of de Kooning's life.**

Sound Byte:

"He had an extraordinary gift for hitting the nail on the head. I made it my point to be influenced by him."

—DE KOONING, on Gorky

Lessons From Gorky

Born Vosdanik Adoian in Armenia on April 15, 1904, Gorky is just nine days older than de Kooning, but the latter immediately feels light years behind his new friend's engagement with and knowledge of art. Simple things impress de Kooning, such as Gorky's studio at 36 Union Square, with its organized profusion of high-quality brushes and paints and ample collection of books. Even the notes and images Gorky has tacked to the walls strike de Kooning as examples of what it means to be an Artist. For the commercially oriented Dutchman

it is a revelation to see how an Artist lives and works. Art is at the heart of their emotionally intense friendship. **Elaine de Kooning** (1918–1989), the artist's future wife, recalled that the evening when de Kooning and Gorky first met, their heated discussion about art nearly led to a fist fight. For the rest of his life, de Kooning acknowledges his debt to Gorky, referring to him as "a real smart cookie."

Gorky is often described as the artist who formed the conceptual bridge between modern European painting and the generation of American painters who would become the Abstract Expressionists. Incorporating abstraction and a fine draftsman's eye, Gorky makes a systematic study of the works of Cézanne, Miró, and Picasso, and brings the lessons he learns to his painting and his conversations.

De Kooning and Gorky are closest during the 1930s and early 1940s, when they both live and work in Manhattan. Gorky's influence can be seen in works such as *Elegy,* with its spare composition and muted tones. This early abstraction echoes the elements of Gorky's approach and will stay with de Kooning for many years: the muted colors, the sense of a clean, flat, yet heavily worked paint surface, and **biomorphic abstraction,** which can be recognized by: (1) **organic shapes** of objects that seem to be living things; (2) **a meandering line** that links forms to each other in an almost cellular way; (3) **a sense that space** is liquid and that the objects are suspended in it.

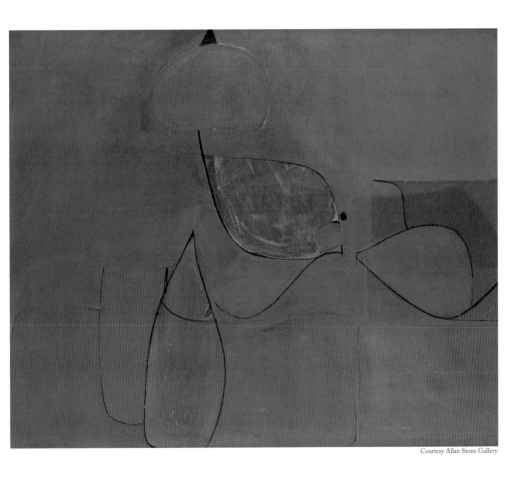

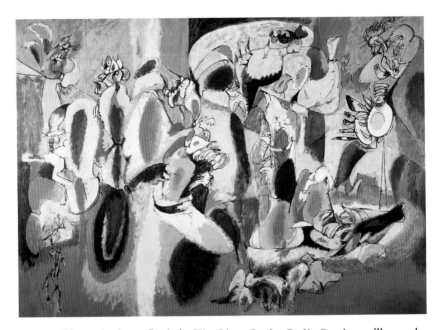

Arshile Gorky
*The Liver Is the
Cock's Comb.* 1944
74 ¹/₄ x 98"
(184.59 x
246.96 cm)

If you look at Gorky's *The Liver Is the Cock's Comb*, you'll see the distinctive formal features of a **dreamlike world**; an **intricate, detailed composition** with lush, sensual colors; a **sense of depth and atmosphere,** but no reference to "real" visual space; **abstract forms** that imply the organic; an **interaction of things and places** that are pocketed yet related; a **complex interrelationship** between drawing and painting; a **nonsensical title** that implies meaning, but that defies logical interpretation or visual reference—i.e., it's very obscure.

Learning the Ropes the Old-Fashioned Way: Looking At Paintings

Like de Kooning, Gorky is deeply interested in the art of the past. The two artists make frequent pilgrimages to The Metropolitan Museum of Art to study their favorites:

- The 19th-century painting wing, home to the subtle and exquisite figures of women by **Jean-Auguste-Dominique Ingres.**

- The ancient art wing, where they see **Roman wall decoration** and **Pompeiian frescoes.**

Sound Byte:

"They went uptown to see Miró, and Bill and Gorky would study these canvases, just lick the paint off the canvases."

—ELAINE DE KOONING

The 1930s: Buddy, Can You Spare a Paint Brush?

By 1935, de Kooning makes several more important friendships. His neighbors, the dance critic and poet **Edwin Denby** and the filmmaker/photographer **Rudolph Burkhardt,** become friends, models, and his first patrons. Denby and Burkhardt spend many a memorable evening prowling the streets of lower Manhattan with de Kooning. During

their nocturnal forays, de Kooning is always on the lookout for the miscellaneous and mundane matter of the streets. He scavenges for what Denby calls "the flash called beauty."

FYI: ***Reclining Nude (Juliette Brauner)***—This nude is more a study of formal volumes than a sexy girlfriend—which she was. The drawing is a merging of the artist's interest in biomorphic abstraction (thank you, Gorky) and his own interest in—you guessed it—the female form.

Denby and Burkhardt buy several important drawings and paintings from de Kooning in those early years. From what we know of de Kooning's destructive tendencies, this probably saved the work from perishing at the hands of its maker.

During the early 1930s, as the country sinks deeper into the severe economic Depression that defines the era, de Kooning works as much as possible, looking at art every chance he gets and painting whenever he can find the time. In 1934, he joins the Artist's Union, one of several art-related clubs he will belong to over the years. For a small monthly fee, organizations like the Union offer people a place to meet, talk, and argue. It is attractive to have this alternative to restaurants and bars, and de Kooning's friends like the privacy offered by a meeting place where they won't get thrown out or distracted by uncomprehending non-art types.

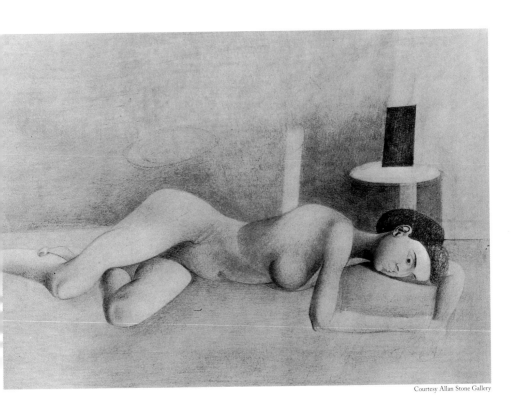

Untitled
c. 1937
Gouache and
graphite on
paper
6 ³/₄" x 13 ³/₄"
(17.1 x 34.9 cm)

In 1935, at the height of the Great Depression, Franklin D. Roosevelt institutes the Federal Arts Project of the Works Progress Administration (WPA). The program is created to make work for artists that utilizes their skills. By 1943, when the program ends, thousands of artists have been employed painting murals and creating art for public places. Artists earn only $23.86 a week, but the program offers many of them their first opportunity to earn a living as artists. De Kooning manages to get onto the payroll of the WPA that first year. (In 1936, Federal laws change and, due to his alien status, he must leave the program.)

During that year, he works with the French artist **Fernand Léger** (1881–1955) on mural projects for the French Line Pier and for the Williamsburg Federal Housing Project in Brooklyn. De Kooning picks up more "How to be an Artist" tips from Léger, whose casual appearance and working man's attitude comfort de Kooning. The French master confirms that art doesn't have to exist in a rarefied atmosphere—one where de Kooning would never feel at home.

After a year on the project, de Kooning gets in the habit of painting full-time and realizes that he doesn't want to go back to his old life. Between 1935 and 1936, the prospect of earning a living as a painter begins to seem possible. Except for the occasional income-producing job, he never again returns to commercial work.

Food or Smokes?

Despite his abject financial situation, de Kooning remembers the years of the Depression as nurturing, formative ones. A sense of shared community prevails, since everyone is poor and none of them is famous yet. Money is something that gets you through the next few days. People have time to talk, and the talk is about art, not about taxes or retirement accounts. As Elaine de Kooning remembers it years later, the normal question is whether to spend the last of your cash on dinner or cigarettes, "Supper or cadmium red?"

Finding a Community

In 1936, de Kooning begins a series of human figures that will occupy him for the next eight years. Painted in a restricted range of colors, the Depression-era figures stand or sit with huge, ghostlike eyes and blank stares. As the only concentrated body of work de Kooning will ever devote to the male figure, the paintings are closely aligned with Gorky's art of the same period. They are de Kooning's first important works and they emerge just as he commits himself to painting full-time.

Two Men Standing

The obsessive working methods that de Kooning employs for the rest of his life get their start in the late 1930s, in works such as *Two Men Standing*. Painting a canvas compulsively, he often begins the day by removing what has been done the day before. He works on canvases for years on end, never taking them out of the studio and changing them time and time again. He mixes safflower oil, water, and other solvents to keep his paint liquid as long as possible, since the different solvents extend the paint's drying time and allow for long working periods. The thinning of the paint means it can be wiped away to a whisper. Covering the work with newspaper at night keeps the working surface wet, but also transfers images from the newsprint to the surfaces of the painting. De Kooning discovers this accidentally and, since he likes the effect, he takes full creative advantage of it. His

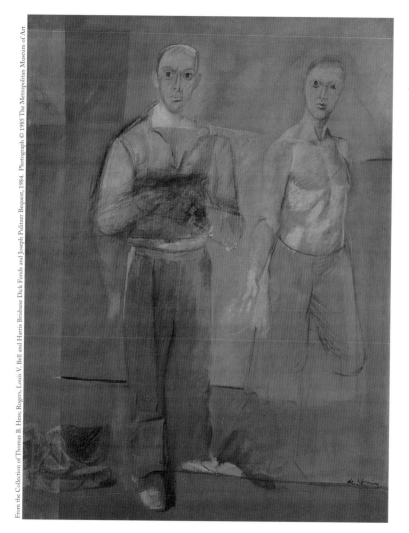

Two Men Standing. 1938
61 x 45"
(153.72 x 113.40 cm)

intent is to learn how to capture in paint a momentary sensation of beauty. He seeks to make great paintings. Notice the haunted, piercing stares of the two men: Their intensity mirrors that of the artist who gives birth to them.

His paintings of Figures often look Unfinished

A lot of ink has been spilled in analyzing de Kooning's apparent "inability" to finish a painting. He gets preoccupied with certain parts of a work, then leaves the rest unfinished. Mostly these paintings are about getting something right—a hand, an eye, or in the case of *The Glazier,* the perspective of someone's lap and the wrinkling of a pair of day-old trousers. De Kooning simply stops working on a canvas when he feels it ceases to hold his interest—or when it is rescued from his clutches by a collector or dealer. Like the other Abstract Expressionists, he considers the ideal of a "polished finish" to be greatly overrated. He is more interested in the *process* than the final product. That's why he sometimes spends years working on a single canvas, painting, scraping, sanding, and repainting, never satisfied.

His First Show

In 1936, the art critic **Harold Rosenberg** (1906–1978) includes de Kooning in the important exhibition *New Horizons in American Art* at MoMA. Rosenberg's show surveys work done for the WPA and is

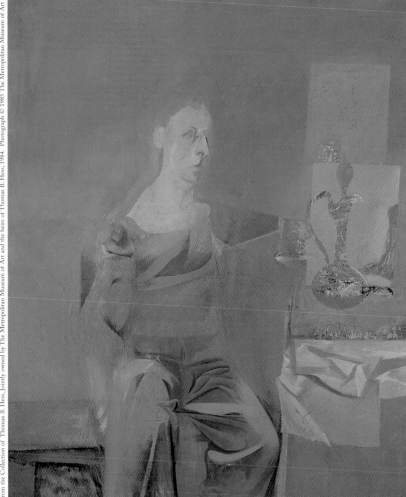

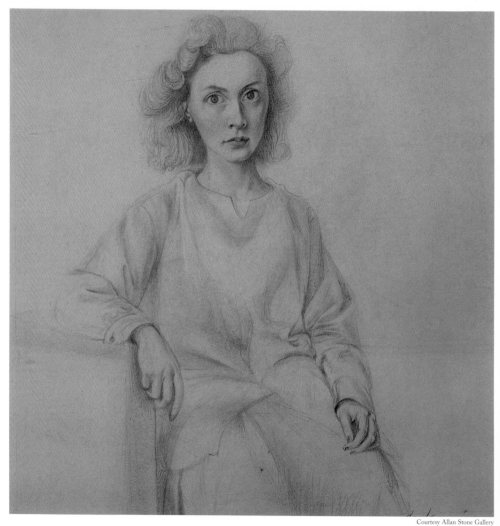

de Kooning's first exhibition. It is also the beginning of a long and supportive professional relationship between the two. In addition to championing de Kooning's work, Rosenberg will go on to become an important force in defining Abstract Expressionism.

OPPOSITE
Portrait of Elaine
c. 1940–41
Pencil on paper
12 $\frac{1}{4}$ x 11 $\frac{7}{8}$"
(30.87 x 29.86 cm)

Falling for an Art Student

The increasingly social de Kooning expands his circle of like-minded artist friends in 1937 when he meets the artists **David Smith** (1906–1965) and **Barnett Newman** (1905–1970). He also hooks up that year with his future wife, **Elaine Fried,** a young art student from Sheepshead Bay, Brooklyn, who, just a year out of high school, is as astonished as de Kooning had been before her to learn that there are "real" artists in the United States.

When she meets him, Elaine is immediately struck by de Kooning's brilliant perceptiveness. "He was more alert visually than anyone I had ever met in my life. He would constantly be pointing out billboards, saying, 'Look at that terrific sign, look at that word *Coca Cola,* isn't that magnificent?'" Like all of de Kooning's important relationships, his involvement with Elaine is based largely on a mutual commitment to art.

In the pencil drawing *Portrait of Elaine,* his model assumes the seated pose that first appeared in *The Glazier* and that will become a preoccupation in his first "Women" paintings. Elaine's face and hands are fully realized, right down to her painted fingernails. Prophetically, she

seems to be missing the important muscle and skeletal system required to support a torso. Her lap appears to be caving in. And those eyes!

OPPOSITE
Seated Woman
1950

> **FYI: Portraits vs. Figures**—De Kooning rarely made portraits of specific individuals. He was a painter of figures, not of portraits. With a few notable exceptions, he wasn't into immortalizing individuals. Instead, he used the body to explore *his* own interests. De Kooning's figures are all about de Kooning.

The First Group of Women

After de Kooning meets Elaine, women start appearing in his work. In the late 1930s, he works simultaneously on male figures, on new images of women, and on the Gorky-inspired biomorphic abstractions. The women who start showing up in his work are related to the men, but they run in very different social circles: These de Kooning gals want to party, and not with the brooding, somber guys that we've seen in his paintings. Gussied up for a night on the town, they sit anxiously by the window, waiting for their dates to arrive. Lipstick, poofy hair, and décolletage are rampant. Sex begins to enter the picture.

Elaine remembers that when de Kooning was working on *Seated Woman* (1950), he became annoyed and stymied by the idea of perspective. He wanted to paint women in a contemporary, American

36

de Kooning

pose, imagining them with their legs drawn up. The foreshortening required to accomplish this feat, however, is said to have made him feel sick to his stomach. (*Foreshortening* is when an artist draws an object to give the illusion of three-dimensional projection into space.) As indicated by the mysteriously disappearing lap in his drawing of Elaine, de Kooning seems to have had recurring bouts of vertigo when faced with the prospect of representing folded limbs.

Sound Byte:

"He would work on paintings for enormously long stretches of time. Just simply be unsatisfied. I would come in and there would be a terrific painting and Bill would grudgingly admit that it wasn't bad, but then say, 'But he has to be moved over two inches,' and then just eradicate it. He was very discontented constantly. It was what kept him going of course."

—ELAINE DE KOONING

Seated Woman is treated to one of de Kooning's favorite house-painter tricks. Laying the piece flat, he applies a thin layer of turpentine to the painted surface and then sands it with a fine grade of sandpaper. The resulting surface is incredibly smooth and polished. After the treatment, the board reveals hints of the lost paintings that exist below the surface. De Kooning then uses these formerly submerged apparitions as cues for the next stage in the process of painting. To get this many

generations of paint on a board, he obviously keeps these pieces in his studio for quite a long time.

Take a look at the areas around the woman's torso and legs. The previous incarnations of the pose are visible and add a subtle feeling of movement or energy to the sitter. This revealing of previous positions makes for an animated surface. Where de Kooning's somber men seem to stand with a stoic reserve, his women often squirm or fidget in their chairs. Presumably this will compound the old vertigo issue.

De Kooning's first "Women" paintings date roughly from 1938–1945. Their arrival announces a new confidence and direction for the artist. His portraits of men, beautiful and ephemeral as they are, contain the hesitancy of an artist unsure of himself. In the first "Women" series, de Kooning begins to lose some of his tentativeness.

New York Becomes the Center of the Art World

During the early 1940s, a tremendous shift of power occurs in the art world. Through technological advancement and economic strength, the world gets smaller and New York surpasses Paris as the vital center of modernist activity. In painting, the most radical and important styles shift from the geometric abstraction of **Piet Mondrian** (1872–1944) and the organic and hallucinatory Surrealism of **Joan Miró** (1893–1983) to Abstract Expressionism, the most original and influential art move-

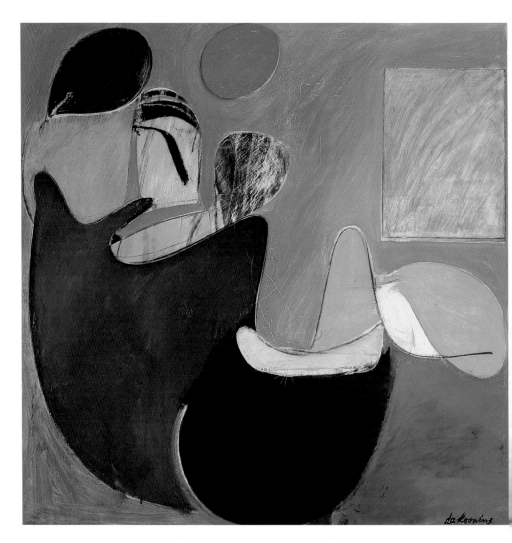

ment America had ever produced. De Kooning and his cohorts find themselves at the front of this turning tide.

Fabulosity on the Rise

When America enters World War II in 1942, the dominant style of painting is still Social Realism, or Regionalism, as represented by such painters as **Thomas Hart Benton** (1889–1975) and **Edward Hopper** (1882–1967). By the time the war is over three years later, abstraction is on the rise. De Kooning plays a role in this shift of power within the art world, but social and economic changes brought on by the war also have a profound effect. Like so many things in life, the luck of timing plays its part.

De Kooning has been described as "an underground force" in the art world during the early 1940s. He is an active participant in the critical dialogue of his time; younger artists know him and he's a fixture in the downtown social scene. The buzz is that de Kooning is a brilliant painter. Too bad, it is often added, that he can't finish a painting to save his life!

The 1942 exhibition, *American and French Paintings,* organized by John Graham, brings de Kooning his first mention in the press. While the value of being referred to as "a strange painter" is debatable, there is no such thing as bad press. De Kooning's reputation is on the rise. The exhibition also proves pivotal when de Kooning makes the acquaintance of one of his fellow exhibitors, a true cowboy.

OPPOSITE
The Wave
c. 1942–44
Oil on fiberboard
48 x 48"
(121.9 x 121.9 cm)

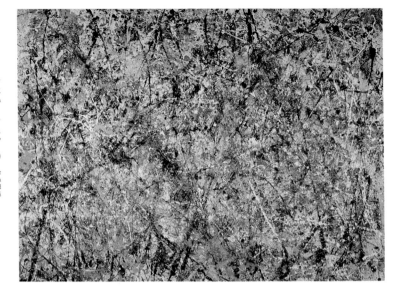

Jackson Pollock
Lavender Mist
1950. Oil, enamel,
and aluminum on
canvas, 87 x 118"
(221 x 299.7 cm)

National Gallery of Art
Washington, DC. Ailsa
Mellon Bruce Fund
Photo by Richard Carafelli

Meeting Jackson Pollock

Jackson Pollock is thirty years old and, like de Kooning, has worked on the WPA. By 1942, Pollock's close affiliation with his mentor, Thomas Hart Benton, and the first of his alcohol-related breakdowns, are already behind him. Surrealism, Jungian therapy, and Mexican mural painting inform his work, which is still representationally based (i.e., you can still recognize human figures and natural forms in it). Like so many of his friendships, de Kooning's relationship with Pollock is intense and volatile. De Kooning's European roots and

social ease are at odds with Pollock's insecurities and isolating nature. The two form a friendship based on competitiveness and mutual respect (a begrudging one on Pollock's part, a more empathetic and ideal one on de Kooning's). In addition to painting, they share one other common behavior—heavy drinking. The surly Pollock and the amiable de Kooning spend many an evening together, bending their elbows, developing arguments, and sizing each other up.

Sound Byte:

> *"He was* It.*"*
>
> —DE KOONING, on Jackson Pollock

Getting Hitched

In the early 1940s, the war is in full swing, everyone is still poor, and de Kooning has turned 40. In December 1943, Bill and Elaine get married at City Hall. At first they live in a loft on 22nd Street, which de Kooning has spent the previous year fixing up for them. In 1944, they are forced to move into a cold-water flat on Carmine Street after being evicted from 22nd Street for owing back rent. Bill moves his work into a studio on Fourth Avenue and continues painting his women. He finishes *Woman* there. With her red finger nails, puffy lips, bulbous

breasts, and socketless eyes, this Woman sits holding her ankle, knees drawn up, looking anxiously out that window. She's also still holding out for that elusive lap.

> **FYI: "-isms"**—Attaching this suffix to a word connotes an alliance to a doctrine, cause, or theory. For artists, -ism usually means that some critic, historian, or wannabe has identified a relationship among a band of contemporaries. Coining a term to encompass a gang of creative peers (usually with the motive of wanting credit for having been the first to see this grouping) gets history organized, spiffed up, and strung along a narrative course. During the modern period in particular, -isms have had a field day. One can understand how an artist might take exception to such a tidy packaging of his or her life's work. Bill detested -isms, as in Abstract Expressionism.

Avoiding Simplistic Affiliations

Having refused to join the American Abstract Artists group in the 1930s, Bill continues to feel uneasy about joining groups or being too closely associated with an –ism. Surrealism is another club he won't join. In the 1940s, he refuses to show at Peggy Guggenheim's Art of this Century Gallery, although he knows and respects **Marcel Duchamp** (1887–1968), **Max Ernst** (1891–1976), and Miró. He feels the gallery is too closely associated with European Surrealism.

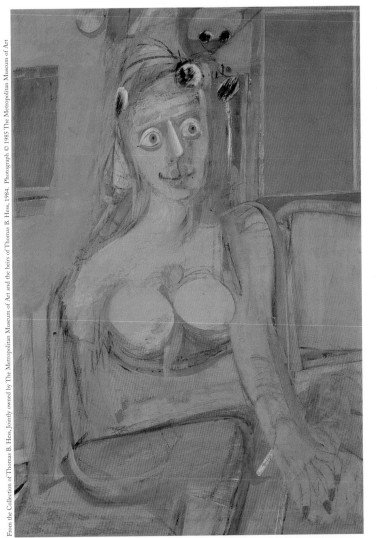

Woman. 1944
Oil and charcoal
on canvas
45 x 32"
(116.8 x 81.3 cm)

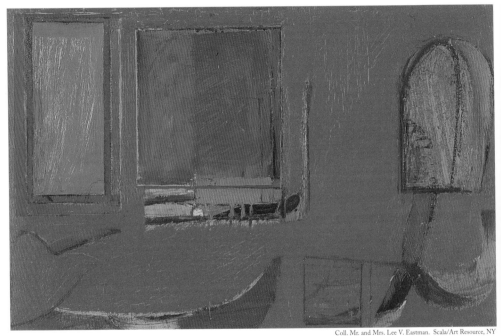

Untitled. c. 1944
Oil and charcoal on
paper, mounted on
composition board
13 ¹/₂ x 21 ¹/₄"
(34.02 x 53.55 cm)

Social clubs, on the other hand, offer a place to meet, talk, and drink, preferably without any expectations, theoretical or otherwise. De Kooning the social animal thrives on the exchange and is a founding member of The Club. Based on the Italian and Greek social clubs flourishing in the immigrant communities of lower Manhattan, de Kooning's idea is to find an alternative to hanging out in cafeterias. The Club is composed of a loosely organized group of artists (*very* loosely organized) who can't even get it together to agree on a name, other than The Club. They do pitch in, however, to rent a loft space on Eighth Street and it becomes the site of some very famous events, drunken and otherwise.

In a roundtable discussion that is filmed at The Club, de Kooning asks critic Harold Rosenberg if his work qualifies him to be called "action painter." (Rosenberg coined the term to describe an activity he saw among a number of downtown painters.) Rosenberg responds that "nobody is actually an embodiment of a category, except bad painters. Bad painters can be reduced by a phrase, a good painter is never identical with any definition." For the next fifty years, de Kooning will prove Rosenberg's dictum correct time and again by never falling easily into any category, group, or *-ism*.

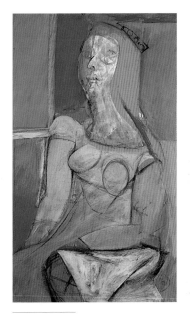

Queen of Hearts
1943–46
Oil and charcoal
on fiberboard
46 ⅛ x 27 ⅝"
(117 x 70 cm)

Ruth's Zowie
1957
80 ¹/₄ x 70 ¹/₈"
(203.8 x 178.1 cm)

Collection of
Mr. and Mrs. Thomas Dittmer

Abstraction hits its Stride

In 1945, de Kooning paints *Pink Angels*, a richly complex image that melds the figure and the landscape into a biomorphic nightmare. *Pink Angels* is a pivotal painting. It is the bridge between de Kooning's figure paintings and the Abstract Expressionism that will define him for the next fifteen years. *Pink Angels* is painted the year World War II ends. Its light colors and feathery markings belie a contorted and rather

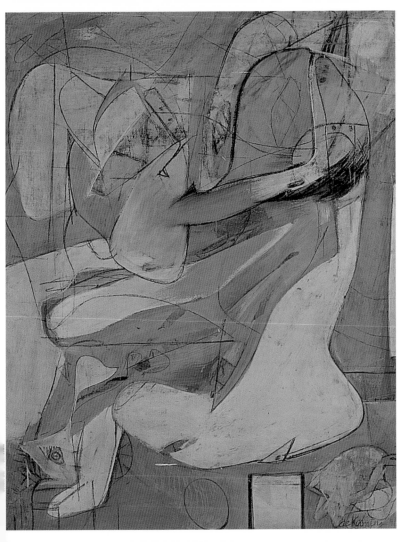

Pink Angels
c. 1945
Oil and charcoal
on canvas
52 x 40"
(131.04 x
100.80 cm)

Pink Angels (Study)
1945. Oil on board
28 ³/₄ x 22 ³/₄"
(72.45 x 57.33 cm)

Courtesy Allan Stone Gallery

gruesome reality. The title (remember though, de Kooning's titles are often ancillary to what you see in the work) is a reference to those killed by the atom bombs. Numerous scholars have pointed out that, like Picasso's *Guernica* (which is also a stylistic influence), this is a painting about the effects of wartime atrocities on individuals.

The figurative elements in the painting are gnarled and misshapen. The central figure turns a tortured head to look over its shoulder at us. To the left of his signature, de Kooning has painted a reference to the landscape in the form of a doorway. Perhaps a metaphorical escape for the souls writhing across the work's surface, the doorway offers some visual stability by holding the painting down and grounding it.

FYI: **Expressionism**—In trying to *express* a subjective response to something, artists often find it useful to distort, manipulate, or ignore reality. One of the goals of art is to convey an emotion or a highly personal point of view. By doing this, the physical things that make up a painting—color, materials, shape, and size—can start to take precedence over narrative content. Expressionism is thus a motivating force in making a work of art; it isn't simply a historical period or specific movement.

JUDGMENT DAY (BACKDROP FOR LABYRINTH), 1946

Oil and charcoal on paper. 22 ⅛ x 28 ½" (56.2 x 72.4 cm)

From the Collection of Thomas B. Hess, Jointly owned by The Metropolitan Museum of Art and the heirs of Thomas B. Hess, 1984.
Photograph © 1985 The Metropolitan Museum of Art

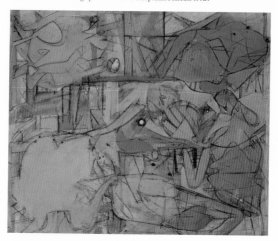

When and Why: From 1946. During the year after the war ended, de Kooning (and everyone else who goes to the movies) sees innumerable newsreels containing black-and-white footage of the atrocities that have played out all over the world.

How: *Judgment Day* is closely related to *Pink Angels* in its redemptive title, biomorphic abstraction, figuration, and heavily interdependent drawing and painting. Notice the flat surface on which, once again, de Kooning paints, sands, paints, and sands some more. De Kooning's champion, MoMA curator Tom Hess, said the painting contained four angels at the gates of paradise.

What else? In 1946, de Kooning is asked to design a backdrop for a dance performance called "Labyrinth." *Judgment Day (Backdrop for Labyrinth)* is the piece he executes for the dance. Perhaps what we've really got here is some dancing angels. Note the crouching, animal-like angel/dancer at the lower right. It looks like a rabbit playing the catcher's position — perhaps a good stance for nabbing stray souls. Humor often lurks in a de Kooning painting, and it's often of the slapstick variety.

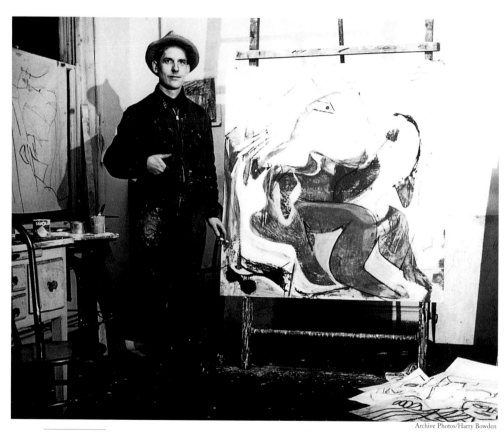

Willem de Kooning
in his studio,
October 1946

Archive Photos/Harry Bowden

In these years of shifting between abstract and figurative modes, de Kooning's confidence continues to grow. As he feels more sure of himself, he destroys less of his work and grows more regulated. In addition to long and concentrated hours in the studio, he focuses on refining the technical skills of his work. He devotes a lot of time to preparing paints and to experimenting with combinations that will keep them wet longer. He tries to replicate colors from memory and perfects some old commercial art tricks to transfer intriguing images from one piece to another:

- He presses wet canvases against clean ones to transfer images.

- He covers drawings with shellac so he can experiment on top of them with easily erased grease pencils, so as not to damage the original source of inspiration.

- He uses vellum (a tough, translucent paper) to trace passages.

Black and White and Read All Over

De Kooning buys a huge supply of black and white house paint in 1948, since he longs for the creative freedom offered by the cheap paint. Without having to be concerned with waste or misuse of expensive materials, he can experiment. As you might imagine, the critics have a field day with this. Everyone has smart ideas about what the lack of color really means. The critic **Clement Greenberg** (1909–1994), the chief supporter of Jackson Pollock, claims that de Kooning is "excluding all irrelevancies." Regardless of the critics' over-determined opinions, the *technique* in the black-and-white paintings is much more important than the lack of color. De Kooning wants to explore his painting methods rather than muddy the waters, so to speak, with color. There is no theory involved—no existential anguish, for instance. If anything, it's a pragmatic way to get to the heart of matter as de Kooning saw it—*how* to paint.

> **FYI:** Many of de Kooning's peers make black-and-white art. It becomes a "thing" for these guys, like a new toy. Kline, Pollock, and **Robert Motherwell** (1915–1991) all warm up to the idea and produce monochromatic work. There doesn't seem to be much behind the coincidence.

Working in black and white has the effect of freeing de Kooning's gesture. The first dramatic sweeps of what might be called **pure action**

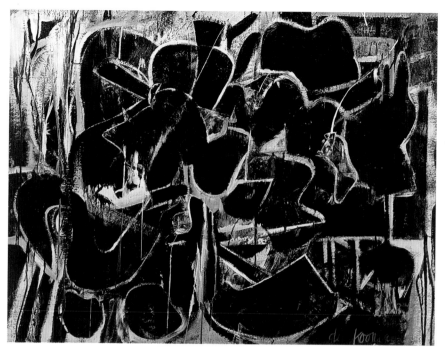

painting appear in works such as *Painting*. When he is most involved with the black-and-white abstractions, de Kooning, the great draftsman, does very little drawing; instead, he merges the acts of drawing and painting, and draws with paint. The forms in these works are related to the biomorphic forms of *Pink Angels*, but since there is no color to divert attention, the strength of the calligraphic gesture becomes the focus.

Painting. 1948
Enamel and oil
on canvas
42 ⁵/₈ x 56 ¹/₈"
(108.3 x 142.5 cm)

The Museum of Modern Art
New York. Purchase.
Photograph © 1999 The
Museum of Modern Art
New York

Zurich

Take a look at the amusing *Zurich*, inscribed with the word ZOT. Words and letters can often be found in varying guises in de Kooning's paintings. *Zot* is slang in Dutch for foolish, as in, "Don't be zot, there it is at the lower right." (When asked why he called the painting *Zurich*, he answered, "Call me zot, but I don't know.")

His First Solo Show at 44

De Kooning is 44 when his first one-person show opens at the Charles Egan Gallery on April 12, 1948. The critical response is favorable. In a review of the show, Greenberg calls de Kooning "one of the four or five most important painters in the country." Sales don't necessarily follow good press, however, and not one piece is sold during the exhibition. But critical attention keeps building. Though collectors are hovering, they are not yet whipping out their checkbooks. They will eventually, but de Kooning must wait until the 1950s for real financial success and security. The buzz does, however, get stronger:

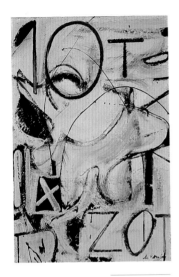

Zurich. 1947
Oil and enamel on paper mounted on fiberboard
36 x 24 ⅛"
(90.72 x 60.98 cm)

Hirshhorn Museum and Sculpture Garden, Smithsonian Institution Bequest of Joseph H. Hirshhorn 1986

- The summer after his show, MoMA buys *Painting*, their first de Kooning and his first museum sale.

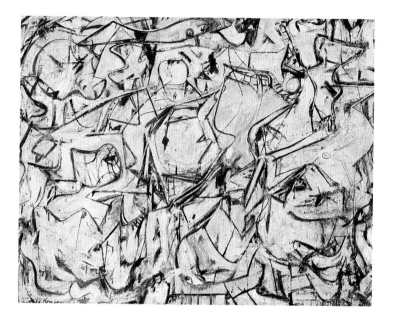

Attic. 1949
Oil, enamel,
newspaper transfer
on canvas
61 $^7/_8$ x 81"
(157.2 x 205.7 cm)

The MURIEL KALLIS
STEINBERG NEWMAN
Collection, Jointly owned by
the Metropolitan Museum of
Art and Muriel Kallis Newman
in honor of her son
Glenn David Steinberg, 1982
Photograph © 1986 The
Metropolitan Museum of Art

- De Kooning's work is included in several large exhibitions from 1948 to 1951, thereby confirming his reputation in the contemporary art world.

- He is selected to be in the 1949 Whitney Annual. (Over the next 40 years he will be selected for 14 more Annuals and two Biennials.)

Following the critical success of the Egan show, de Kooning enters a period of concentrated painting that will result in two of the most important canvases of his career, *Attic* and *Excavation*.

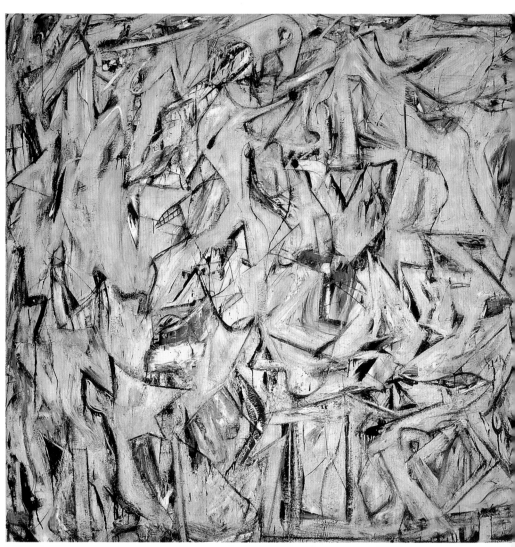

The frenetic energy and dense space of *Attic* seems to house an even more combustible group of figures and objects than we saw in *Judgment Day.* De Kooning names the painting *Attic* because he feels it's a canvas in which everything is stored—the junk and the gems. It's a crowded, noisy piece that relies for its success on an equal compositional weight across its surface. Rather than having a central focus, the chaos and agitation of the painting keep the viewer's eye moving and off-balance. This type of allover composition has become a hallmark of Abstract Expressionism.

Excavation is the culmination of de Kooning's postwar abstractions. This canvas reintroduces colors in primary shades and is perhaps de Kooning's most dense work. As the painting surface implies—and as Webster's defines it— "to excavate" is to "expose to view by digging away a covering; a cavity formed by cutting, digging, or scooping." Scoop, cut, and dig he does.

Excavation. 1950
81 ⁷/₈ x 102 ¹/₈"
(206.2 x 257.3 cm)

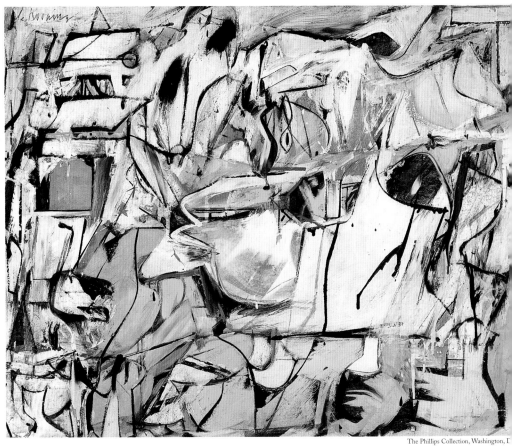

With *Excavation* and *Attic,* de Kooning reaches the quintessential moment of his Abstract Expressionist work. The intention and impact of these large (for de Kooning) canvases brings his work as close as it will ever come to Pollock's. Never again will he be so easily identified, or so unconditionally lauded.

Expressionism, Yes...But is it Really Abstract?

De Kooning's painting always maintains its own quirky fidelity to the real world. Recognizable subject matter and natural references abound, and looking for them in one of his paintings is a good way to enter his work. Even de Kooning's titles support this approach on occasion. A conventional reference in a title such as *Attic* gets the conceptual ball rolling and the canvas gives the eye something to search for.

The visual triumvirate of de Kooning's oeuvre consists of the figure, the landscape, and the sea. But there are also mundane objects around him that he sees as beautiful. These include signs, newspaper stands, cracks in the wall, and stains on the sidewalk.

One of the beauties of de Kooning's painting is its combination of representing the accessible—the figure or the landscape—with a bolt of emotional energy. These elements are expressed with extraordinary skill.

OPPOSITE
Asheville
1949. Oil on illustration board
15 ½ x 32"
(64.7 x 81.2 cm)

A Roster of Professional Achievements and Personal Changes

In the late 1940s and early 1950s, de Kooning is at the top of his game:

- The displaced Bauhaus master, **Josef Albers** (1888–1976), invites de Kooning to be a guest teacher at the influential Black Mountain College during the summer of 1948.

- Following a series of personal and professional tragedies, Gorky hangs himself at his studio in Sherman, Connecticut, in July 1948.

- De Kooning makes his first trip to East Hampton in the summer of 1948, spending a weekend with Kline, Egan, Pollock, and Pollock's wife, artist **Lee Krasner** (1908–1984). After this visit, the Hamptons become de Kooning's place of refuge.

- Alfred Barr, the influential curator of MoMA, includes four of de Kooning's major paintings in the 1950 Venice Biennale. This is de Kooning's first— and most prestigious to date—exposure in Europe.

Woman
1953
Oil and charcoal
on paper, mounted
on canvas
25 ⁵/₈ x 19 ⁵/₈"
(65 x 49.8 cm)

Hirshhorn Museum and Sculpture
Garden, Smithsonian Institution
Gift of Joseph H. Hirshhorn, 1966

More Women, More Hormones

The black-and-white paintings and the color abstractions of the late 1940s have generally garnered the critical accolade "de Kooning's best work." In the popular imagination, however, de Kooning will always be the painter of the restless women of the 1950s.

After his stint at Black Mountain, de Kooning once again focuses his energies on women. He paints two distinct series of women between 1947 and 1955: The first series is painted between 1947–49, while the second one is done between 1950–55. Sometimes the women are alone, as the first women had been, but occasionally they appear in groups of two (watch your elbows, missy), as in *Two Women in the Country.*

Woman (1948) is the first important of the group of women. Her animated torso and heavy outlining come directly from

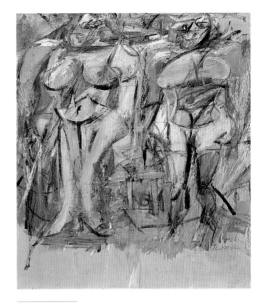

Two Women in the Country
1954. Oil, enamel and charcoal on canvas
46 ⅛ x 40 ¾"
(116.30 x 102.69 cm)

Hirshhorn Museum and Sculpture Garden, Smithsonian Institution
Gift of Joseph H. Hirshhorn, 1966

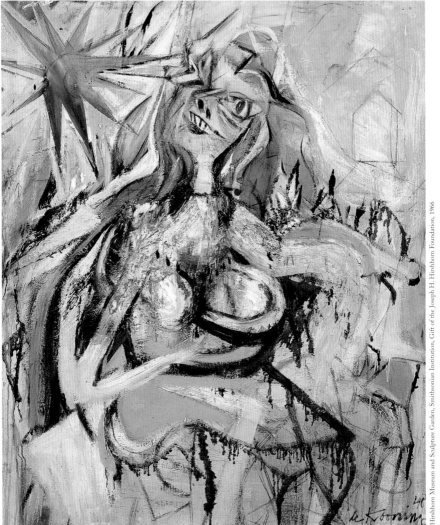

the black-and-white abstractions. Situated in an unusually overt landscape, this woman seems to be contemplating nature. She's another seated, lapless wonder, though she sports a fetching knee-length pink skirt—is this a fashion statement or a cover for yet another fit of the old folded-leg vertigo? Sitting outside, downhill from the simple outline of a house (notice the international symbol for "house" lightly sketched at the upper right), the woman looks up at the star that dominates the entire upper-left quadrant of the picture.

Compared to her cohorts of a decade earlier, this woman is fresh. She's part of the postwar world and she's angling for a different sort of attention. She's not waiting anxiously for something to happen. She's all over the place. Consider her face for a moment. Wild-eyed and toothsome, de Kooning employs one of Cubism's favorite tropes: she's walleyed! (Cubists loved to displace the eyes.) What a gift that is: She can simultaneously look at us looking at her, while still enjoying that star, low in the sky, that lured her outside in the first place.

About the breasts: They are large and (on the whole) rather in-your-face. De Kooning has a thing for this variety of bosom. Like the rest of her, the breasts agitate for attention. Nothing shy about this woman! When it comes to sex, the amorous de Kooning isn't what you'd call subtle. (Someone once asked de Kooning if a portrait he did of Marilyn Monroe revealed his subconscious lust for her. His paraphrased response was, "Subconscious, my ass!") If the earlier women

OPPOSITE
Woman. 1948
Oil and enamel
on fiberboard
53 $^5/_8$ x 44 $^5/_8$"
(135.07 x
112.39 cm)

were flirts, these dames seem to want to skip the preliminaries and get down to business. Afterwards, however, when you're smoking that cigarette, it's worth noting that while the woman may be about sex, they don't score big points in the erotic competition.

OPPOSITE
Woman I
1950–52
6'3 ⁷/₈" x 58"
(192.7 x
147.3 cm)

Now let's employ a tried-and-true art historical technique: Ignore the sexual details and talk about everything else. In painting women, de Kooning tackles one of the most loaded subjects in the history of Western art: These gals bring a ton baggage to this relationship, and for an artist with de Kooning's love of art history, that's the attraction. The critic Sidney Geist wrote in 1953 that the female image exists "in the vast area between something scratched on the wall of a cave and something scratched on the wall of a urinal." Like the prehistoric drawings on the walls of caves, these women are monumental archetypes. Like the scratches in the bathroom stall, they are de Kooning's boorish salute to the female figure.

Woman I emerges

An important woman was patiently awaiting her moment of glory. De Kooning begins his most famous canvas, *Woman I,* in June 1950, just as his masterpiece *Excavation* is packed up and shipped to Venice for exhibition. *Woman I* introduces the women at their most mannered. The paintings made between 1950 and 1955 pull out all the stops. Whereas the earlier group of women (1947–49) still have stylistic

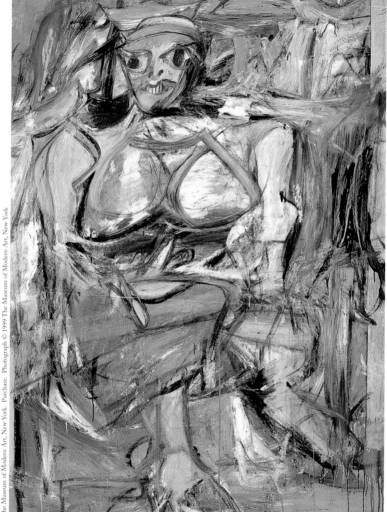

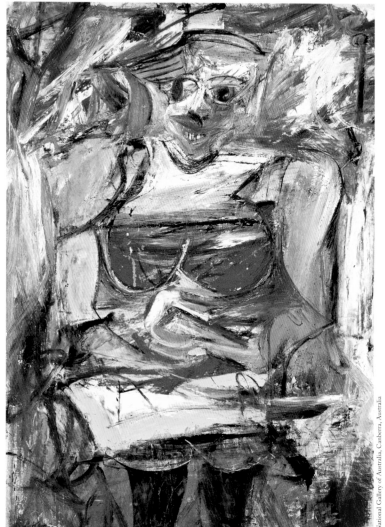

similarities to the black-and-white abstractions, the second group announces a colorful and over-the-top turn of events.

Six Bouts of Surgery

OPPOSITE
Woman V
1952–53
61.31 x 45.44"
(154.5 x 114.5 cm)

Over the course of two years, de Kooning paints, ponders, and scrapes clean the surface of *Woman I* innumerable times. Six of the painstaking stages *Woman I* goes through are documented. This series of images is an exceptional tool for understanding, or at least getting a glimpse of, de Kooning's working method.

By repeating the process of painting too often on a canvas, the result can often be the loss of the work entirely. With *Woman I*, de Kooning finds himself so perennially dissatisfied with the canvas that he relegates it to the hallway outside his studio door.

The rejected painting is discovered and saved by the highly regarded art historian **Meyer Schapiro** (1904–1996), who pays de Kooning a visit during this time. After Schapiro's visit, the artist goes to work again and, by June 1952, brings the canvas to its current state.

Women On Parade

"Paintings on the Theme of Women" opens at the Sidney Janis Gallery on March 16, 1953. The show includes 6 paintings, 16 pastels, and works on paper. The show is nothing but women. The lips, eyes,

mouths, feet, and breasts are there, along with the lipstick, nail polish, high heels, and fashionable frocks.

The trappings of modern American womanhood fascinate de Kooning. High-heeled shoes and long red fingernails contain all the power of a fetish. The women of the early 1950s have a lot in store for the contemporary viewer: nudity, pret-à-porter, and popular imagery. Another important and often overlooked fact is their **humor.** On the whole, these women are more about having a great laugh than they are about transgression or sin.

So, was he a Misogynist?

These women have been known to make viewers flinch. The debate has always been whether this was meant as play or aggression. De Kooning was often asked about his "true" feelings toward women in light of his apparently violent portrayal of them. Unveiling the "rot at the root" of de Kooning's all-too-obvious misogyny was the lightly veiled goal.

Who *was* the woman? Why did de Kooning treat her this way? In what may well have been a defensive moment, Elaine responded that "the ferocious woman he painted didn't come from living with me. It began when he was three years old." But she felt the energy and animation in the paintings had more to do with paint than with psychology. One thing to keep in mind is that de Kooning always sized himself up against the big guys in art history—the top-of-the-

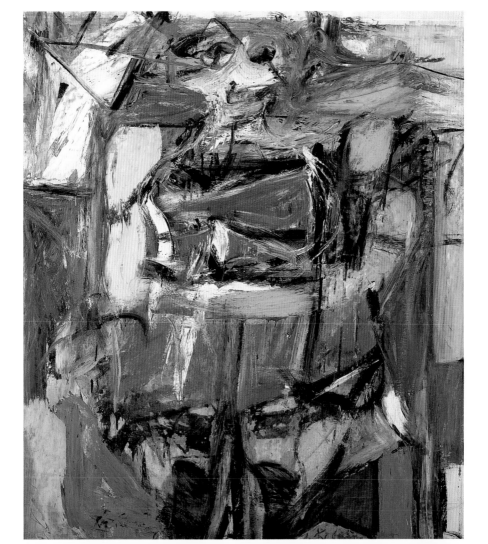

Questions: Where is the bicycle? And what does the woman have around her neck?

Answers: De Kooning loved to bicycle. He and Elaine would often ride around the Hamptons. The image of a girl on a bicycle, like the woman with her legs drawn up, intrigued him. This particular woman tends to overshadow her vehicle, and you do have to wonder why she's peddling around in high heels; but there are signs (granted, they're weak) of a bicycle in the lower half of the painting. At some point in the process of painting, de Kooning moved the figure out of the way and left her original mouth. In its current placement, the nonmouth mouth becomes a necklace mouth, thus leading to the conceptual ploy of "Which is the *real* mouth?" De Kooning enjoyed this device. He made many a *necklace mouth.*

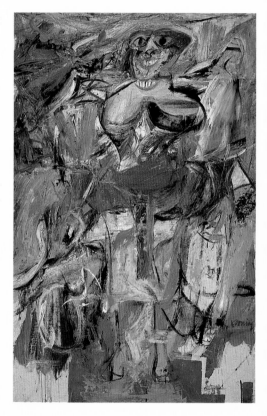

top-tier kind of stuff. To hang out with them (or, more accurately, next to them), he wanted to paint women and show what he was made of. In addition to painting them in relation to art history, he knew he had to paint them in relation to his own time, for to be important art has to have both current relevance and historical staying power.

So sure, there is aggression, even hostility, but how does that translate into an analysis of an artist's psychological make up? De Kooning once made the comment that his paintings were the Jungian representations of the women inside him. But do we — in all our collective unconscious wisdom — need to go there? To the question of misogyny, de Kooning would concede only that a slight annoyance at women might have found its way into the paintings.

At the end of the day, it is a gross oversimpliciation to assess the paintings merely as illustrations of his tortured relationship with women. This view smacks of a sort of visual literalism and it reduces the art to a one-dimensional Rorschach test. This critical approach does what de Kooning tried so hard to avoid: It wraps everything up into one neat little package, labels it, and puts it on a shelf.

Betrayal by Representation

The Museum of Modern Art heralds Abstract Expressionism's official entry into the canon by organizing the exhibition "Abstract Painting and Sculpture in America" in 1951, thereby affirming AbEx's impor-

tance and influence in art history. The movement thus enters the hallowed halls of Art History. Why? Surprise! In the modern period, the act of canonizing usually has dollar signs attached to it...and as many dollar signs as possible.

The Art Institute of Chicago acquires *Excavation* as a purchase prize for its prestigious Logan Medal in 1951. Awarding the coveted prize to de Kooning causes quite a stir in Chicago, where the painting is received less than enthusiastically by the local power players. (Irony factoid: The painting is now one of the most important works in the museum's collection.) While all this was happening to de Kooning's greatest abstract painting, he is busy painting women. (You can almost hear the dealers hissing, "After all these years, just when he starts selling and getting a reputation, he goes and paints broads.")

Despite abstraction's acceptance in certain rarefied circles, it's not like abstraction was a universally appreciated art form in the early 1950s. When de Kooning shows his women at the Sidney Janis Gallery in 1953, other abstract painters question his choice of painting the figure, but the generally odious reception he receives has less to do with painting women than it does with *how* he paints them: ugly and raging.

Sound Byte:

> *"You* know *more, but I* feel *more."*
> —JACKSON POLLOCK, to de Kooning

The show causes a critical uproar at The Club. It is rumored that Pollock voices his disdain at the party following the opening: "You're doing the figure, you're still doing the same goddam thing. You know you never got out of being a figure painter."

From Coffee to Beer to Brandy

In the early days of hanging out in the coffee shops of Greenwich Village, talk was cheap and caffeine kept it going. At some point, though, the bottomless cup of coffee is replaced by the ever-present bottle. In the late 1940s and early 1950s, the scene shifts from the Waldorf Cafeteria to the Cedar Street Bar on University Place, and the party really starts rocking. Periodic benders are a part of de Kooning's m.o. The social lubricant induces everyone, even the cantankerous Mr. Pollock, to lighten up. As de Kooning later recalled, "Pollock was suspicious of any intellectual talk. He couldn't do it—at least not when he was sober. But he was smart though—oh boy—because when he was half-loaded, that in-between period, he was good, very good, very provocative."

In de Kooning's case, the drinking is periodic, but becomes more pronounced over time, as he begins to see cocktails as medicinal. On the advice of a doctor, de Kooning starts drinking brandy in the morning to stave off the **acute anxiety attacks** that have begun to plague him. The cure, as he puts it, "worked good, it stopped the attacks, but I became a drunk." A drunk he would remain until well into his seventies.

Sound Byte:
"Content is a glimpse of something, an encounter like a flash."
—DE KOONING

Snatching that Elusive Glimpse

So guess what happened in 1955? De Kooning changes course again. He stops painting women and starts painting a series of highly abstracted urban landscapes.

Capturing the essence of a thing is de Kooning's oft-repeated visual goal. As many people have described, walking down a street with the artist could be a concentrated lesson in "The Visual World According To Bill." Crumpled newspapers, piles of garbage, billboards, and oil stains all get his undivided attention. The beauty he sees in the city's flotsam and jetsam works its way into a series of abstractions with a distinctly urban point of view.

Capturing the Neighborhood

De Kooning wants to capture in his work his experience with the visual culture of lower Manhattan. A painting such as *Easter Monday* (on page 79) refers to a moment and an experience around the artist's Tenth Street studio the day he finishes this painting, the day after Easter. The urban landscapes are more broadly painted than the tightly knit abstractions of the late 1940s. The two new dominant features are **color**—so much color—and **a freer brush stroke**. (De Kooning's interest in color and painterly abandon had started appearing in the last group of women. Now the city environment offers him the visual cues to explore these two interests more abstractly.)

Thirty-One Flavors: de Kooning Chooses a Color

De Kooning spends huge amounts of time trying to replicate colors from memory, the color of boiled liver as he remembers it from the markets in Holland, for instance. "I thought if Gauguin made figures yellow and Picasso painted some blue ones, what the hell, I was going to use flesh color. After all, flesh was the reason why oil paint was invented!"

Sound Byte:
"I got the idea for preparing colors that suit my particular way of painting one day at Howard Johnson's: the ice cream makers."

—DE KOONING

De Kooning is **attracted to different palettes** during the various phases of his career:

- His earliest abstractions have been characterized as being made of "high-key color."

- His male figures are unique for their somber, earthy tones.

- The first women series and the abstractions of the mid-1940s are characterized by an intense variety of hues.

- The largely black-and-white works arrive during the second half of the 1940s.

- In the paintings of the 1950s, 1960s, and early 1970s, de Kooning is a master of color. They drip with emotion, shock with force, and jar with vibrancy, particularly in his urban and pastoral landscapes.

- De Kooning's last work is characterized by a honing both of the range of color and of its intensity. The primary colors dominate, and the compositional forms of the late paintings read like ribbons of color flowing across the surface of the canvases.

His passion for color is magnificently on view in *Gotham News* (see page 80). The work describes a newsstand that Bill and Elaine frequented somewhere between de Kooning's Tenth Street studio and the neighborhood now known as Battery Park City, in downtown Manhattan. De Kooning and his wife would pass the newsstand on

Easter Monday
1955–56
Oil and newspaper
transfer on canvas
96 x 74"
(241.92 x
186.48 cm)

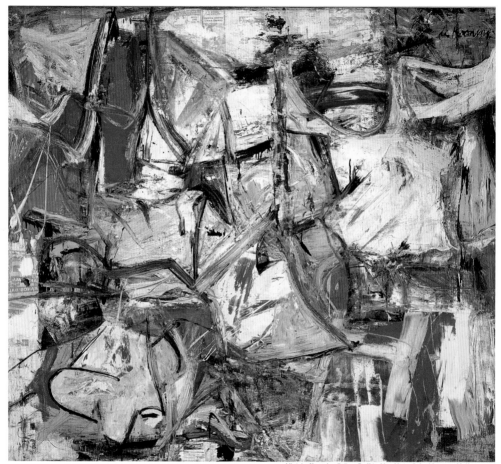

Bowery and take in the hubbub of animated clutter. The magazines and newspapers fighting for attention are the perfect de Kooning metaphor for catching a glimpse of something. All these periodicals are designed to beat each other out and catch *your* eye. The newsprint transfer is easily visible at the upper center and lower right side of the canvas.

On the Road and In the Hamptons

If catching a glimpse of beauty is de Kooning's goal, what better place to be flooded with fleeting images than riding in a car? He never learns to drive, but de Kooning is a rapt passenger, mesmerized by the monotony of driving. For three summers beginning in 1951, Bill and Elaine are the guests of art dealer Leo Castelli and his wife, Ileana Sonnabend, at their home in East Hampton. These retreats cement de Kooning's love for the South Fork of Long Island. From here on in, he spends as much time in the Hamptons as possible, and the drive out and back offer him an abundance of visual material. His love of the highway and its signs prompts him to name one of his canvases *Montauk Highway* (p. 83).

1956 is a Tumultuous Year

By the mid-1950s, de Kooning is making money and pulling in the honors—as well as having extramarital affairs. 1956 is also a year of shake-ups:

OPPOSITE
*Montauk
Highway*
1958. Oil and
combined media
on heavy-weight
paper mounted
on canvas
59 x 48"
(149.9 x 121.9 cm)

- After their marriage drifts apart for several years, Bill and Elaine formally separate, though they never divorce. As Elaine puts it, "We went our own separate ways for a couple of decades."

- De Kooning becomes a father. His daughter **Lisa de Kooning** is born in January to girlfriend Joan Ward.

- Pollock dies in a car crash in The Springs, East Hampton, on August 11, drunk behind the wheel; the accident kills one young woman (Edith Metzger) and seriously injures another (Ruth Kligman).

Backlash: Abstract Expressionism starts to Implode

As the 1950s wane, the postwar years give way to the rock-'n'-roll years. Eisenhower is replaced by Kennedy and irony becomes the preferred means of expression for the younger generation. Heroism and monumentalism are out. Ultimately de Kooning is saved by his humor and his understanding of the place where popular and high culture intersect, but it's tough going for a while. His 1959 show at Janis is a sellout, though some people prefer to use the phrase metaphorically.

In 1958 and 1959, the show "The New American Painting," organized by MoMA, travels to eight European cities. Suddenly everyone is an Abstract Expressionist. Imitation may be the sincerest form of flattery, but it can interfere with the way we look at art. As the paintings become popularized and homogenized, action painting starts to look inoffensive at best, haggard and worn out at worst.

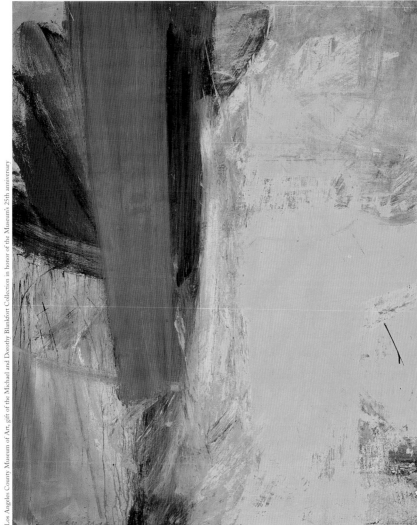

JACKSON POLLOCK, 1928

WILLEM DE KOONING, 1946

FORMS OF MACHISMO:
THE COWBOY VS. THE EUROPEAN SOPHISTICATE

Some comparisons between the work of Pollock and de Kooning, the two masters of Abstract Expressionism:

(1) Method: De Kooning makes tracings and works methodically to create the semblance of spontaneity in his canvases. Pollock avoids compositional planning before starting to paint; he prefers to work quickly and fluidly.

(2) Style: De Kooning paints vertically, like an old-fashioned easel painter. Pollock works horizontally, with his canvas on the ground so that he can walk around it, avoiding an up-and-down orientation.

(3) Tone: De Kooning never goes in for those over-the-top huge canvases; his paintings tend to be more human-scaled. Pollock paints enormous, mural-like canvases that dominate the viewer by their sheer size.

How the Personal Life stands up to all the Assaults

The late 1950s and early 1960s continue to be full of personal transitions. Tired of the scrutiny of the New York art world, de Kooning spends more and more time in the Hamptons. He buys a house in The Springs, near East Hampton, where he spends as much time as possible with daughter Lisa and her mother Joan.

The Sixties

Given the climate in New York, de Kooning is reluctant to sell and show his work. He turns down an invitation for a retrospective from MoMA in 1959, since he feels that retrospectives—which are meant to salute the culmination of a career—treat the artist "like a sausage, tie him up at both ends, and stamp on the center 'Museum of Modern Art,' as if you're dead and they own you." He eventually agrees to the retrospective a few years later.

Milestones of the Early 1960s:

- Spends the winter of 1959–60 working in a friend's studio in Rome.

- Visits San Francisco for the first time in 1960 and makes first lithographs at Berkeley.

- Is elected to the National Institute of Arts and Letters in May 1960.

- Becomes an American citizen on March 13, 1962, finally.

- Franz Kline dies on May 13, 1962.

- His 1962 show at Janis is not well received.

- Falls in love with Susan Brockman.

OPPOSITE
Door to the River
1960. 80 x 70"
(203.2 x 177.8 cm)

Retreat to The Springs

By June 1963, Bill lives year-round in the Hamptons with his new companion, **Susan Brockman.** In the early 1960s, he designs and builds a new home and studio—a place that finally suits his demanding needs. He wants something entirely new, not another worn-out, make-do loft, like all those he has inhabited for years. He creates the studio to be the fulcrum of the house, the heart of the matter. Pushing 60, he deserves it.

Pastoral Landscapes

The artist finds life in The Springs "all sun, sky, earth, and sea." The landscape of his new home becomes his visual haven, and his new life settles into a pleasant, productive groove. He rides his bike to nearby Louis Point and, as always, watches and absorbs. Landscapes such as *Door to the River*, which grow out of his earth-and-water reverie, pick up where the parkway pictures leave off, with big, animated brush strokes and a horizonlike stability (and, in the case of *Door to the River*,

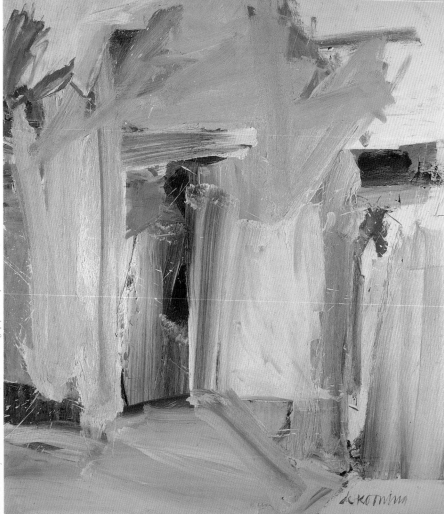

GIRL IN BOAT, 1964
Pencil on tracing paper. 9 7/16 x 7" (23.89 x 17.64 cm)

Hirshhorn Museum and Sculpture Garden, Smithsonian Institution, Gift of Joseph H. Hirshhorn, 1966

The Image: A nude young woman floats recumbent in a small rowboat with her legs and arms flung over the sides in an unmercifully casual pose. The most formal part is her hair: It appears that she has rushed home from the beauty parlor, with some overwhelming hankering for a naked boat ride.

The Medium: The drawing is made on tracing paper, a de Kooning favorite. The image was probably transmuted through several generations of drawings via tracing, as the artist explored the pose. A de Kooning drawing is rarely a self-contained entity, but is more likely to be a passage in an evolving story.

The Composition: De Kooning must "float" above the water to capture the angle on this one. The rowboat floats on a sea of tracing paper, while its open-mouthed inhabitant makes direct eye contact with us.

an illusionistic doorway smack in the middle of the canvas). Between 1960 and 1963 the landscapes have a spontaneity and bigness.

The Urban Dames Move to the Country

Then come some more women. Gushing, exuberant, fleshy women. This time around, he even throws an occasional man into the mix. Most of the 1960s figures are nude and tend to float in water—or just plain float! Their genitals are often explicitly rendered. For de Kooning, this is an uncommon subject matter.

Sound Byte:
"I felt everything had to have a mouth. A mouth is a very funny thing."
—DE KOONING

The most cohesive paintings from this period are commonly referred to as the "Door Paintings" because they all measure roughly 80 x 36 inches. In works such as *Woman Accabonac* (see next page), done on thick vellum mounted on canvas, the nude figure hovers above enormous feet. Her fleshy form seems to hold liquid while at the same time being suspended in it. De Kooning feels good when making these paintings: His skill, his eye, and his mood are in synch.

ABOVE
Seated Woman
1966–67
Charcoal on paper
18 1/4 x 23 1/4"
(43.47 x 58.59 cm)

Collection of the Newark
Museum/Art Resource, NY

RIGHT
Woman Accabonac
1966. Oil on paper
mounted on canvas
79 x 35"
(200.7 x 88.9 cm)

Whitney Museum of American Art
Purchase, with funds from the
artist and Mrs. Bernard F. Gimbel
Photography by Sheldon C. Collins
N. J.

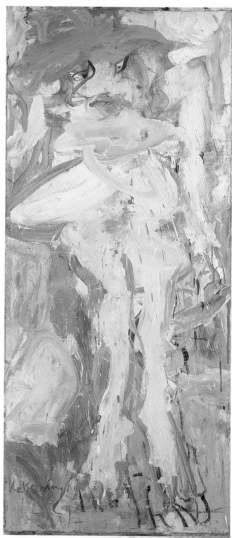

Willem
de Kooning
c. 1968

Busy, Busy, Busy

While the revisionist critique of his work continues to gather steam, honors and international recognition keep coming as well and de Kooning maintains a busy schedule:

- In 1964, he receives the Guggenheim International Award and the Presidential Medal of Freedom from President Johnson. His response, "What on earth have I done for freedom?"

- In January 1968, he visits Paris for the first time to see an Ingres exhibition and visit the Louvre. He returns from Paris via London, where he visits the artist Francis Bacon, whose claustrophobic paintings he admires enormously.

91

NEAR RIGHT
Willem
de Kooning
with
The Visit
1966

FAR RIGHT
The Visit
1966–67
60 x 48"
(151.20 x
120.95 cm)

OPPOSITE
Montauk I
1969
88 x 77"
(221.76 x
194.04 cm)

Archive Photos

Tate Gallery, London Art Resource, NY

- In September 1968, he returns to Holland for the opening of his first traveling retrospective. It's his first trip home since he sailed off in 1926. He sees his 91-year-old mother, who dies shortly after his visit.

- January 1969, de Kooning visits Japan, where he travels to Osaka with sculptor and designer **Isamu Noguchi** (1904–1988).

- March 3–April 27, 1969: The retrospective that originated in Holland opens in New York at MoMA.

- He spends the summer of 1969 in Italy, where he makes his first sculptures.

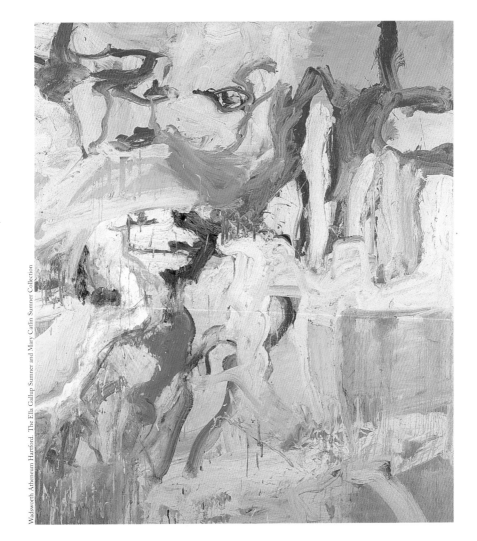

DE KOONING'S "WOMEN"

Early Women, 1938–45: These first women make their appearance on the heels of de Kooning's taking up with Elaine. They relate to Depression-era men in their biomorphic and Gorkylike references, but their high-key color and fashion accessories announce a new direction.

Women II, 1947–49: Falling (sort of/mostly) in the period between de Kooning's most accomplished abstractions (*Judgment Day,* the black-and-white abstractions *Zurich* and *Attic,* and *Excavation*) the postwar women acquire a charge and intensity that grow out of the breathtaking technique de Kooning perfects when working on the abstractions.

Women III, 1950–55: These are the women who mark de Kooning for life, since they are the harpies the world associates with him. In spite of their power and importance, it is unfortunate that in the popular imagination de Kooning's career often gets pared down to this relatively brief moment.

Women IV, 1960–63: These figural women are the disconcertingly vacant, eager-to-please figures that came to him in his new country home.

Woman on "Doors," 1964–66: Often done on heavy vellum, these highly interrelated compositions begin when de Kooning receives a shipment of doors for his new studio. He hates the fact they are hollow doors, but he's stuck with them. Their shape, as they stand stacked and rejected in his studio, inspire him.

Pastoral Women, 1965–69: The early part of this period, 1965–67, is devoted to some highly agitated women posed singly or in pairs. In the second half of the period, 1967–69, agitation gives way to a topsy-turvy amalgamation of figure and landscape. In the later works of this period the environment seems to be devouring the women, and ultimately succeeds in ingesting the figure. From here on out, the landscape and the water become de Kooning's captivating muse— that is, after he passes through a brief, anomalous period of **sculptural figures** (1970–73), which feature primarily male figures. De Kooning's passion then focuses on the landscape that surrounds him.

Willem
de Kooning
Summer 1967

Archive Photos

FYI: Tidying things up—When Tom Hess, the reigning expert on
de Kooning's work, organizes a retrospective of de Kooning's art for
MoMA, he succeeds in bringing order to de Kooning's complicated
and tumultuous career. For the 30-year period from 1934 to 1965,
Hess distills de Kooning's career down to fifteen bodies of work, an
average of two groups a year.

Trying His Hand at Sculpture

At age 65, de Kooning finds himself drawn to working in clay. The malleable nature of the material appeals to him and he can push clay around to his heart's content. Unlike paint, if it dries out it is easily revived by a dousing of water. Encouraged by his results, the artist tries his hand at life-size sculpture.

The figures are as contorted as those in his paintings, yet they resonate with a sense of solidity and formal mass. *Clamdigger* is de Kooning's riff on the guys he saw poking around for crustaceans at the beach near his home, weighed down as they trudge in from the flats. The sun makes heavy objects appear to shimmer, and, for de Kooning, that is an irresistible combination. Composed of writhing, floating bits of clay, this guy reminds us of the "Door" paintings, such as *Woman Accabonac.*

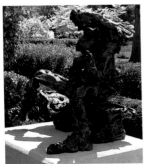

An Astonishing Burst of Work

In 1975, de Kooning suddenly makes 20 large paintings and thus enters a period of great confidence. ...*Whose Name was Writ On Water* (the name is taken from the English Romantic poet John Keats's tomb in Rome) epitomizes

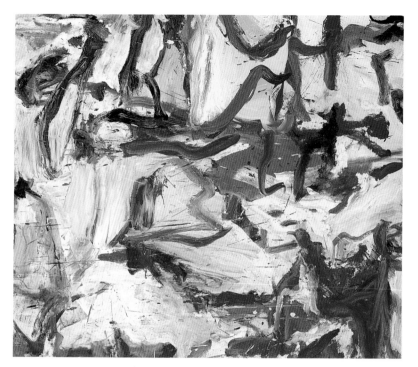

the beauty of these land and seascapes. They are, once again, evocations and intimations of places; they set a tone and hint at a memory of other times and other places. De Kooning rejoices in painting a place that inspires him and that he is less and less inclined to leave,

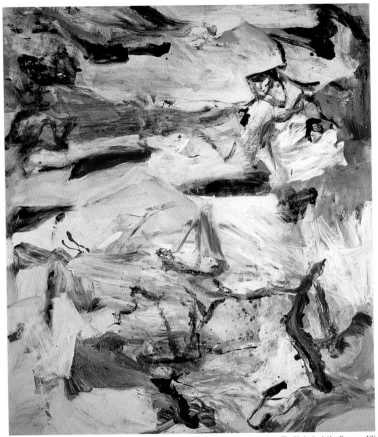

especially as the short trip to Manhattan holds little appeal. *North Atlantic Light* is one of an extraordinary group of canvases that de Kooning accomplishes in quick, fluid, confident succession. Check out the middle of the canvas: See the overwhelmed sailboat? The atmosphere of the painting is enormous, as though de Kooning wants to fit in every emotion and image of nature.

OPPOSITE
North Atlantic Light. 1977
80 x 70"
(203.2 x 177.8 cm)

Titles and Tricks of His Trade

- By 1975, de Kooning calls most of his pieces *Untitled,* followed by a roman numeral. This doesn't mean much in terms of chronology, since his habit is to work on one canvas, while keeping the other recent ones around, occasionally even returning them to the easel for a tune-up.

- Though he still hates the idea of completion, Bill signs the stretchers of canvases as they leave the studio, not when they are taken off the easel. Fewer and fewer of the canvases are signed at all.

- In the 1970s, he uses an overhead projector to transfer passages he likes from one canvas to the next.

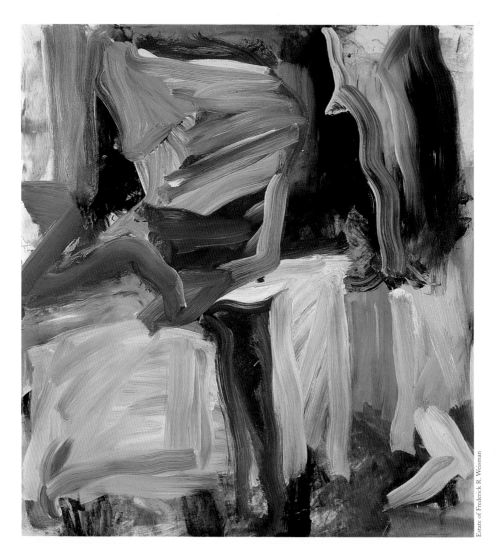

Things Aren't Always Peachy

- Bill continues his lifelong habit of drinking and is surrounded by people who enable his destructive behavior. He is hospitalized and has frequent blackouts.

- When his old friend and champion, Tom Hess, dies in July 1978, de Kooning feels more alienated than ever from the art world. (Hess's collection of de Kooning paintings forms the basis of the Metropolitan Museum of Art's important de Kooning holdings.)

- Bill's intelligence and wit have always been a social tool and now he uses them as a way of keeping people at arm's length.

- Elaine moves back to East Hampton in 1975 and, by 1978, moves in again with de Kooning. The motivation for the move is to get de Kooning dried out. After forty years of ever-increasing alcohol consumption, de Kooning's health is succumbing to the toxic effects of booze. What began as good-natured socializing has degenerated into prolonged binges that are often accompanied by withdrawal, violence, and blackouts. Elaine had struggled with her own drinking problem a few years earlier. Her recovery, coupled with her intimate knowledge of de Kooning's life and habits, make her the right person for the job. Under Elaine's protective—some would say overprotective—supervision, changes are made in the studio and in the social structure of de Kooning's life. She scrutinizes all invitations

OPPOSITE
Untitled III
1979. 60 $\frac{1}{4}$ x 54"
(153 x 137 cm)

and makes choices based on what is least stressful for her husband. Someone is with him all the time.

- By the late 1970s, people who know the artist well comment on his social withdrawal, forgetfulness, and short-term memory problems. His active alcoholism makes it difficult to gauge when and if any true mental deterioration may have started.

Bill Gets Sober

In the studio, employees who have worked and partied with de Kooning for years are let go and replaced with sober assistants. New inventory systems are instituted. De Kooning's supplies of paints and specially designed canvases are restocked. An even more advanced easel system is designed and installed that allows him to move and turn his canvases unassisted.

For two years, de Kooning focuses on regaining physical and mental stability. The panic attacks that had played an early part in cementing his drinking habits return, now accompanied by bouts of rage. Anti-depressants are necessary when the despondency brought on by withdrawal is intense. De Kooning works only sporadically between 1978 and 1980, and very little of the work that was made then survives.

The slow process of recovery causes much pain for Bill and requires the ever-watchful eye of Elaine. De Kooning needs constant supervision

and distraction, but the program works. After a prolonged period of depression and mood swings, de Kooning emerges sober. And sobriety turns out to have some wonderful results.

Criticism of the Late Work

In the 1970s and 1980s, the critical backlash continues. De Kooning's champions see a man entering his golden years, confident and working in his own direction. Those critical of the work see confusion and incoherence. In the 1980s and 1990s, the merits of the works from the 1970s become generally accepted, but the paintings of the 1980s receive more critical attention than any other work, and for a specific reason: There is a persistent rumor in the art world, beginning at the end of the 1980s, that Bill suffers from Alzheimer's disease, yet these rumors are founded on gossip and speculation, not on medical proof. A medical diagnosis of Alzheimer's disease can only be made upon autopsy. To this day, it is unknown whether de Kooning indeed had Alzheimer's disease, and it is irrelevant in the appreciation of his oeuvre.

The Last Work—Holding Water in His Hand

In 1980–81, de Kooning begins painting with another burst of captivating energy. Enthralled by Matisse's late work, his post-1980 paintings have a **musical quietude** easily aligned with the French master's paper cutouts. De Kooning admires and attempts to emulate Matisse's

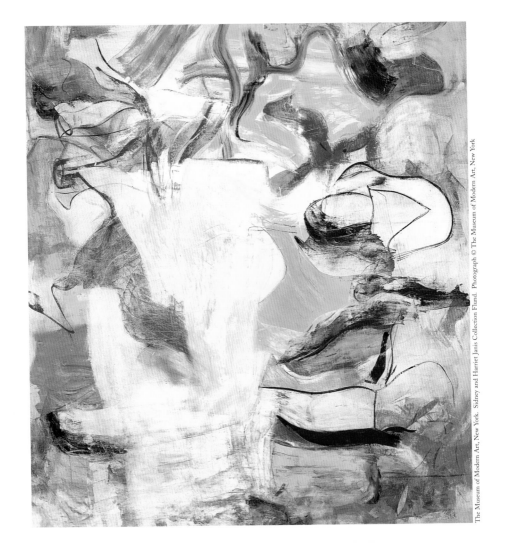

ability to make it look easy. One of the first new works the newly sober de Kooning finishes is *Pirate (Untitled II)*. Some have suggested that he gives the painting this title as an homage to Gorky, who, in the early 1940s, made a pair of paintings of the same name. As it turns out, Gorky's "Pirate" paintings were named after his country neighbor's dog, Old Pirate. De Kooning's studio assistant at the time recalls that the title referred to the shape of the white sail in the center of the canvas. Whatever the title's origin, the implication is a seascape and refers to de Kooning's fascination with the Long Island landscape.

Stylistically, the painting reflects a **completely new, pared-down approach to his art.** Over the course of the decade, de Kooning's palette becomes progressively simpler, his paint thinner, and his touch more subtle.

In 1984, de Kooning is commissioned to make an altar painting for a church in Manhattan. He completes a large triptych in 1985, but ultimately submits an entirely different work to the congregation: In an insightful moment, he cobbles together *Triptych (Untitled V, II and IV)*, on pages 18-19, from three independent canvases. But the commission is withdrawn after a spate of

Archive Photos/Chris Felver

ABOVE
Willem de Kooning
1984

OPPOSITE
*Pirate
(Untitled II)*
1981
7'4" x 6'4 3/4"
(223.4 x 194.4 cm)

internal conflicts in the church regarding the appropriateness of using an abstract painting that had no direct relation to the church.

OPPOSITE
Untitled II
1986. 88 x 77"
(223.5 x
195.6 cm)

Alzheimer's: Gossip and Conjecture

In the late 1980s, de Kooning withdraws further into his own world, recognizing fewer and fewer people. Despite the growing confusion from which he suffers, he continues to make up to one large canvas a week. The last known film footage showing de Kooning at work dates from about 1986. It is important, since it confirms that de Kooning himself—and not some studio assistant—is making his paintings.

In 1986, he creates *Untitled II*, which contains characteristics that relate to some of his earlier works. Like the black-and-white abstractions painted forty years earlier, the abstract *Untitled II* employs an allover composition. It is a fundamentally white painting that incorporates thin ribbons and areas of primary colors, which suggest relationships to de Kooning's Abstract Expressionist masterpiece, *Excavation.* It's cell-like forms and connecting threads are reminiscent of his earliest experiments with biomorphic abstraction. In late 1987, de Kooning's paintings change yet again. The **colors are more vivid,** the artist's hand is bolder, and the composition is looser. The de Kooning estate has not exhibited any of the artist's post-1988 works.

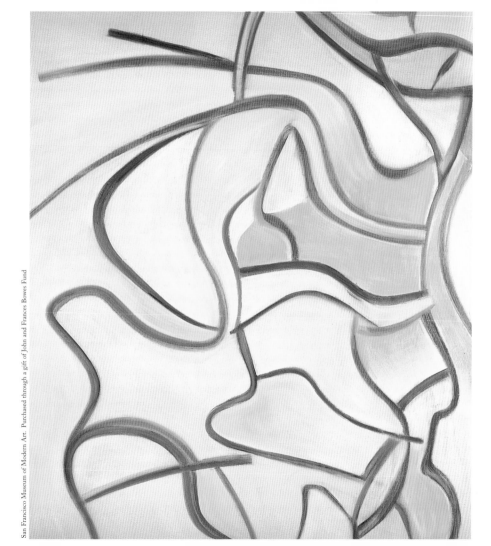

Death of Elaine

On February 1, 1989, Elaine de Kooning dies after a protracted battle with lung cancer. At her death, de Kooning loses the strongest remaining tie to his own history and work. From the beginning, Elaine and Bill shared many passions, including art and each other. Their commitment to art—and to Bill's art, in particular—sustained their relationship, even during their decades-long estrangement. Elaine's complete belief in the power of Bill's work can be seen both in his influence on her own painting and in her willingness, after almost twenty years spent pursuing her own career, to return to Bill and devote her considerable energies to helping him work in his last productive years. Before they picked up their life together again in 1975, however, Elaine made a name for herself as a critic, teacher, and painter outside of the immediate shadow of her more famous husband. An accomplished portrait painter, she was commissioned to immortalize John F. Kennedy in 1963. (The commission was left undone when the president was murdered, and in the wake of that experience, Elaine stopped painting for a year.)

The Last, Solitary Years

In 1989, the effects of de Kooning's deterioration take a firm upper hand. As he continues to slip away, Lisa de Kooning and her lawyer, John L. Eastman, are appointed the artist's guardians and executors.

De Kooning stops working entirely in 1990, spending most of his time with his daughter or under professional supervision. In the last years of his life, four museum exhibitions are devoted to his work. One of them, "Willem de Kooning: The Late Paintings, the 1980s," is on view at MoMA when he dies on March 13, 1997, six weeks shy of his 93rd birthday.

The Complexity of the Abstract Expressionist Inheritance

The monumental and romantic myths that spring up so easily around the Abstract Expressionists grow from a belief in creative heroism that is based as much in the historical milieu of post-World War II America, as it is in the artists who defined the era. With some help from economic and political shifts after the war, Willem de Kooning and his peers of the 1940s and 1950s accomplished what, just forty years earlier, seemed truly impossible: They made American art the most important art in the western world. The repercussions of this seismic shift in power from Europe to the United States are still felt, debated and agonized over to this day.

De Kooning's major Innovations

To a large extent, de Kooning's genius lies in his innovative use of the classic and the traditional:

OPPOSITE
<*no title*>
1987
80 x 70"
(201.6 x 176.4 cm)

Collection Willem de Kooning
Revocable Trust. Photograph
by Christopher Burke
Quesada/Burke, New York

- He drew, but sometimes with his eyes closed.

- He used oil paint and varnishes, but pushed them to their limits by keeping them wet and sanding them away to traces.

- He used paintbrushes, but left huge swathes of their progression along the canvas as important elements of a composition.

- He painted figures and landscapes, but changed our visual understanding of these subjects through his use of abstraction.

- He painted easel style and on a (comparatively small) human scale, but with his radical use of paint and composition, he changed the parameters of painting.

Willem de Kooning: Abstract Expressionism and Way Beyond

From being a precocious commercial art student in Holland, to reigning as one of the foremost painters in the world, Willem de Kooning captures the imagination as the quintessential artist. His process of visual discovery started with his earliest, tentative steps toward creative expression and continued to drive him right up until his health made it impossible for him to work.

The breadth of de Kooning's achievement easily transcends one all-encompassing title. The maker of the masterpiece *Excavation* and the inventor of *Woman I* followed a creative course which can be said to

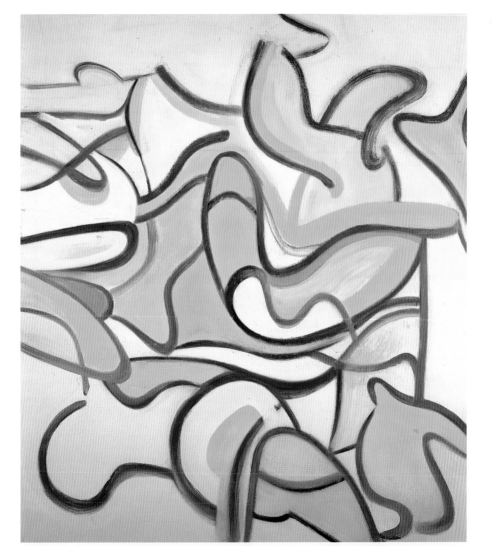

have followed the course of the 20th century. De Kooning learned his trade in a small historic city in Western Europe before setting out to discover the larger world. From there, the momentum built as he kept pace with the art movements that pushed modernism forward. The Great Depression of the 1930s leveled the playing field and gave de Kooning the chance to hone not only his talents, but his belief in himself. World War II opened people's eyes to the powerful emotional impact of abstraction. In the 1960s, the wry humor that underscored so much of de Kooning's output was seen anew within the sly context of popular culture. In the 1970s and 1980s, with his place in the pantheon of art history firmly established, de Kooning retreated a bit from the world of art, but continued his compelling inquiry into the nature of vision and human experience.

De Kooning's quest to capture a glimpse of transient beauty embodies the profound importance of the momentary and the fleeting. As the work of a superb draftsman, an Abstract Expressionist, a landscape painter, and an artist of the human figure, de Kooning's oeuvre carries with it the simple and brilliantly clear objective of holding for a moment that which cannot be held—the ephemeral experiences that make up a life.